IMAGES
of America

OKLAHOMA CITY
LAND RUN TO STATEHOOD

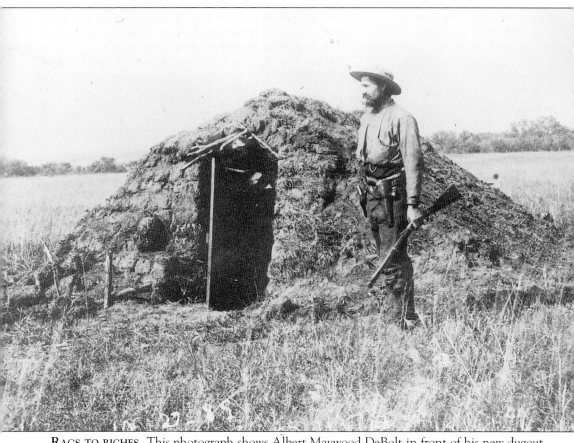

RAGS TO RICHES. This photograph shows Albert Maywood DeBolt in front of his new dugout home, October 17, 1889. With shotgun in hand, he was ready to fend off any claim-jumpers. His lot would be located on East Reno. (A.M. DeBolt Collection of the Archives & Manuscripts Division of Oklahoma Historical Society, Oklahoma City.)

IMAGES
of America

OKLAHOMA CITY
LAND RUN TO STATEHOOD

Terry L. Griffith

ARCADIA
PUBLISHING

Published by Arcadia Publishing
Charleston, South Carolina

Printed in the United States of America

Library of Congress Catalog Card Number: 99065106

For all general information contact Arcadia Publishing at:
Telephone 843-853-2070
Fax 843-853-0044
E-mail sales@arcadiapublishing.com
For customer service and orders:
Toll-Free 1-888-313-2665

Visit us on the Internet at www.arcadiapublishing.com

To my mother
Magnolia Dustman Griffith
(1937–1993)
May her memory be eternal

CONTENTS

ACKNOWLEDGMENTS

It is difficult to express thanks adequately to all those individuals who were of assistance in compiling this work. I would like to thank my family and friends, who gave moral support, in particular my dad, Lee Griffith; my godparents, Herb Ham and Gloria DeLeon; and my spiritual fathers, Rt. Rev. Father Constantine, Father Basil, and Father Christopher of St. Elijah Antiochian Orthodox Christian Church. For their contribution to the work, I would also like to thank: my co-workers at the Harn Homestead & 1889er Museum; Carol Hazelwood; Jessica Bufkin; a very special thanks to Wendell "Farmer Rusty" Bowen and Kimberly Wageman for helping to sort the photographs; to those who met my deadlines; John Nichols for his legal advise; Bill Welge, Chester Cowen, and Carrie Goeringer at the Oklahoma Historical Society; to Ken Corder at the Oklahoma Department of Transportation; Dr. Joe Coley; Captain Charles Coley and Don Boulton for photograph identification. Special thanks to my editor, Jeffrey J. Lutonsky, for being patient with me and last but not least, all my best go to Stephen Thornhill and Melvin Caraway.

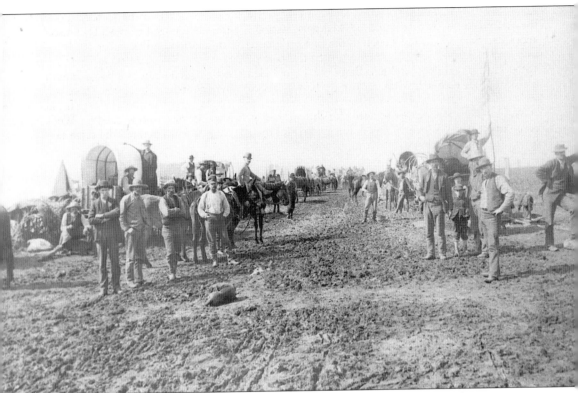

GREAT ANTICIPATION. Home seekers are depicted in this image waiting at the Kansas state line on April 18, 1889. This photograph was taken by William S. Prettyman of Arkansas City, KS. (Beavers Collection of the Archives & Manuscripts Division of OHS.)*

INTRODUCTION

Francis Haines wrote in the April 1973 issue of the *Western Historical Quarterly*: "Historians say that history needs to be rewritten for each succeeding generation, not because history has changed, but because the new generation is asking new questions that can be answered by an examination of records of the past from a new viewpoint." So, here it goes.

The beginning of Oklahoma City is unique. When the last Indian reservation was established in Indian Territory in 1881, there remained, in the heart of the territory, a tract of nearly 2 million acres known as the Oklahoma Country or Oklahoma District. This tract of unassigned lands extended from present Stillwater in the north, to Norman in the south, Reno City to the west, and the Indian Meridian to the east. Splitting the unassigned lands was the Atchison, Topeka & Santa Fe Railroad (A.T. & S.F.), today known as the Burlington Northern & Santa Fe.

Traditionally, railroads build their lines to cities the size of Oklahoma City rather than the cities coming to the railroads. Oklahoma City is located where it is today because of the railroad, which began service through Indian Territory in 1886. The name must not be overlooked. People from other states who came to the unassigned lands by railroad did so by purchasing tickets to the Oklahoma Country, and quite logically, bought a ticket to the station, along the Santa Fe line, by that name of Oklahoma Station. Postmaster General Don M. Dickinson appointed Samuel H. Radebough as the first postmaster of the station on December 30, 1887, followed by J.C. McGranahan who turned the post office over to G.A. Biedler on April 22, 1889. The residents of Oklahoma Station, I.T., included a boardinghouse run by George Gibson and a stockade owned by C.D. Bickford, who was a government contracted freighter. There was an army quartermaster agent, Captain C.F. Sommers, and a cottage for four agents: 18-year-old A.W. Dunham, who served as agent for the railroad; three young men who worked for Wells Fargo Express and Western Union Telegraph; and the stage agent who operated the stage line from Oklahoma Station to Ft. Reno, I.T.

Author's Note: An asterisk appears after the captions of photographs that have never been previously published.

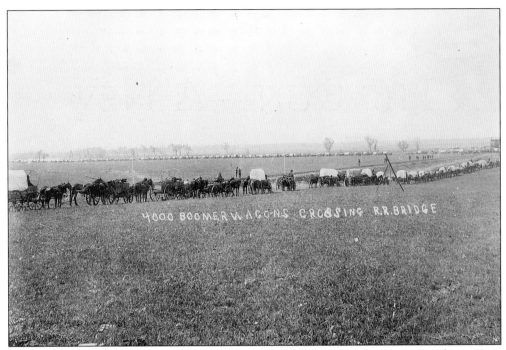

WHAT A SIGHT. Four thousand "Boomer" wagons are illustrated here crossing the A.T. & S.F. Railroad bridge across the Salt Fork River on April 20, 1889. (Archives & Manuscripts Division of OHS.)

Resources and Selected Readings

For more information on the scenes in this book or to order reproductions of these images, contact Mr. Terry Griffith, PO Box 1702, Oklahoma City, OK 73101-1702. For further reading on Oklahoma City and its history, consult the sources below:

Blackburn, Dr. Bob. *Heart of the Promised Land. Oklahoma County, An Illustrated History.* Woodland Hills, CA.: Windsor Publications, 1982.

Blackburn, Dr. Bob and Paul B. Strasbaugh. *History of the State Fair of Oklahoma.* Oklahoma City: Western Heritage Books, 1994.

Edwards, Jim, Hal Ottaway and Mitchell Oliphant. *The Vanished Splendor, vol. I, II, III.* Oklahoma City: Apalache Bookshop Publishing Co., 1982, 1983, 1985.

McRill, Albert. *And Satan Came Also.* Oklahoma City: Semco Color Press, 1955.

Proceedings at the Dedication of the Carnegie Public Library, August 29, 1901. Oklahoma City.

Rock, Marion Tuttle. *Illustrated History of Oklahoma: Land of the Fair God.* Topeka: C.B. Hamilton & Sons, 1890.

St. Luke's. *Witness to a Loving God.* Oklahoma City: St. Luke's United Methodist Church, 1989.

Scott, Angelo C. The *Story of Oklahoma City.* Oklahoma City: Times-Journal Publishing Co., 1939.

Stewart, Roy P. *Born Grown.* Oklahoma City: Fidelity Bank, N.A., 1974.

One

THE RUN—A NEW BEGINNING

In 1866, a council was held at Ft. Smith, Arkansas, to open the unassigned lands to settle friendly American Indian and freemen. The lands, however, were not used for that purpose but remained the property of the government, awaiting congressional action. From 1866 to 1870, little was done to influence Congress to open these lands. On December 14, 1880, Captain Payne broke camp at Bitter Creek, Kansas, and moved to some 35 miles south to Caldwell, where they were joined by a large number of recruits. The troops moved with the settlers without interfering with their movements. It was there that a petition was prepared and forwarded to the president, asking that Payne and the others be allowed to enter the Territory. Neither the president nor Congress could be swayed to render aid to the settlers, and they soon became disheartened. Soon after, Payne was arrested and charged with trespassing on American Indian lands, and deprived of their leader, the colony temporarily disbanded. Payne's trial was held at Ft. Smith, where the validity of the treaty of 1866 was brought into question. The attorneys and the secretary of the interior differed, but eventually they agreed and found Payne guilty, holding him on $1,000 bail, which he paid and returned to his home in Kansas.

Payne made four additional trips to bring groups of colonists into Indian Territory, where they built houses and farms and planted crops. At each time they were driven out by U.S. troops. His last expedition was made in early 1884, when he and a colony of 500 people with 250 wagons settled in the Stillwater District. This time Captain Payne was arrested and taken before the United States Court at Topeka, Kansas. The court decided that no crime was committed, and Payne was determined to organize additional colonists and take them into the Oklahoma Country but would not make any. On the morning of November 28, 1884, while at breakfast, he fell dead in the arms of one of his faithful followers.

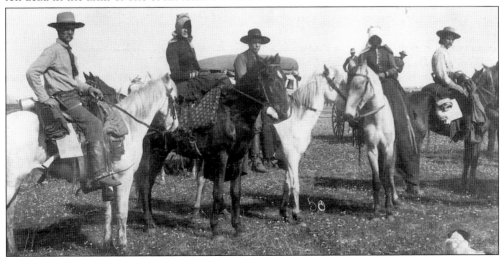

ON YOUR MARK. . . Riders are seen here preparing for the run on April 22, 1889. (Voth Collection of the Archives & Manuscripts Division of OHS.)

9

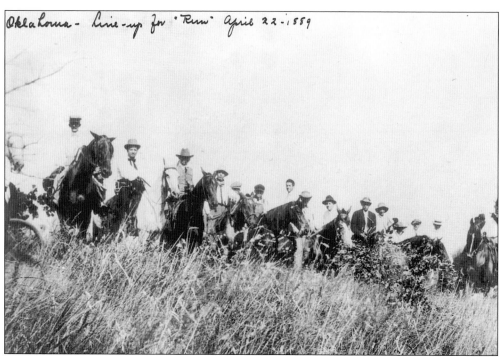

Oklahoma - Line-up for "Run" April 22-1889

GET SET . . . The line-up for the first land race in the United States, known as the "Run of 1889," can be seen in this rare photograph. (Archives & Manuscripts Division of OHS.)

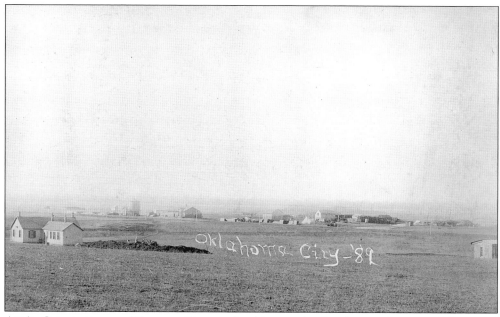

Oklahoma City -'89

ALL'S QUIET ON THE WESTERN FRONT. Looking to the Southwest, this peaceful view of Oklahoma Station was taken the day before the race on April 21, 1889. (Griffith Archives, Oklahoma City.)

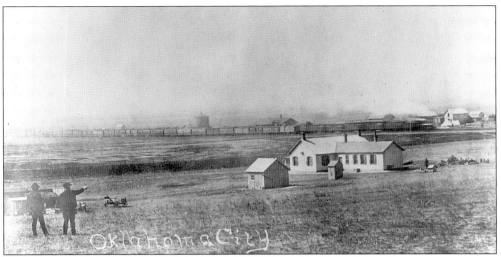

THE DAY BEFORE. Looking to the Southwest, this view shows outgoing Postmaster James McGranahan (to the right) pointing out to the new postmaster, G.A. Beidler, his future domain—Oklahoma Station. The A.T. & S.F. Railroad began service through Indian Territory in 1886. (Mrs. J.M. Owens Collection of the Archives & Manuscripts Division of OHS.)

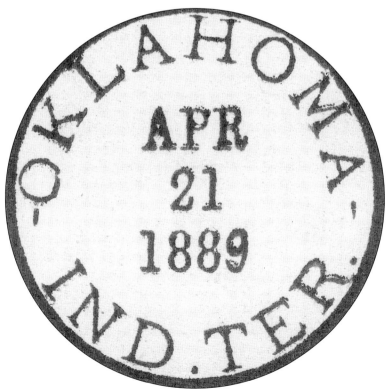

POSTMARKED—THE DAY BEFORE. This cancellation stamp was used by Postmaster James McGranahan at Oklahoma, Indian Territory before the Oklahoma Country was opened to settlement April 22, 1889. This stamp was used until 10 a.m. Sunday morning, at which time he turned the post office over to his successor, G.A. Beidler. (Griffith Archives.)

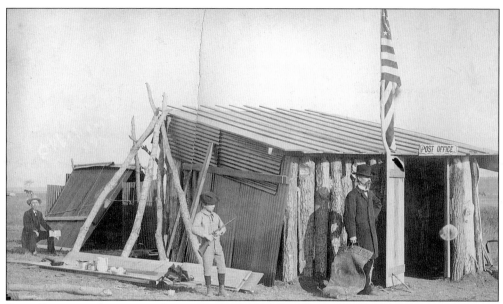

POST OFFICE AT OKLAHOMA STATION, 1889. G.A. Beidler is seen here holding a mailbag in front of his makeshift post office. He purchased the lumber for the construction of this post office only for $5. His son, Chase, is standing with a .22 rifle with Sheriff DeFord in the background. (Griffith Archives.)

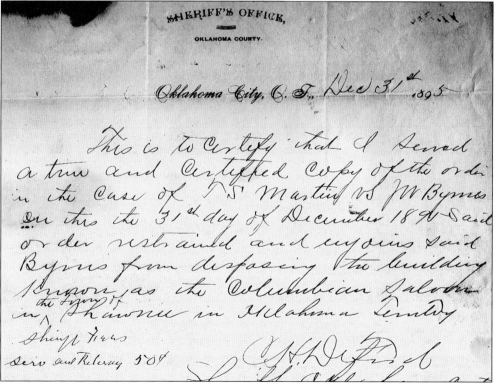

C.H. DEFORD, SHERIFF, 1895. This document shows proof that the sheriff served a true and certified copy of a warrant. (John Dunning "Okie Archives," Oklahoma City.)

Two

First Things First

On the 2nd of March 1889, the Indian Appropriation Bill was passed with a "rider" opening to settlement about 2 million acres known as the Oklahoma Country. It was signed by President Grover Cleveland, and on the 22nd of the same month, President Benjamin Harrison issued his proclamation that the Oklahoma Country would be opened to settlement on April 22nd at high noon. He warned all parties not to enter upon such lands prior to said day and hour. As noon approached on Monday a serious question arose as to the exact time of day. There was no official guard and no official timepiece. Watches were consulted and found to vary as much as 30 minutes. At 12 noon, Oklahoma Station (City) was born, and by 6 p.m., she had a population of around ten thousand citizens.

As with any birth, there are many firsts—first foods, first toy, first step, first word, etc.—and so was the case with Oklahoma City. The first marriage recorded in Oklahoma City was conducted by Rev. James Murray when W.W. Wilkerson and Miss Mary Moore tied the knot on Thursday, May 16. The first sermon was given on Sunday, April 28, by Rev. C.C. Hembree at the corner of Main Street and Broadway Avenue. The first recorded birth was on Sunday, May 2, when Mrs. J. Cunningham brought a daughter, who she named Oklahoma Bell, into the world. The first fire occurred on Deep Fork River in the shanty of a man named Newton, on September 3. The first horse race was Saturday, May 18, when Texas Belle beat Shadow Tail. The first burglary occurred on the night of June 5, when Dr. Scott, of Scott & Co., was held up. The first baptism was that of George McKay by the Reverend T.J. Head, in the North Canadian River, on the July 7. The first hanging (accidental) occurred in the summer of 1889, when "Rip Rowser" Bill, was left alone with a noose around his neck. The early morning dew had tightened the rope and he lifted 6 inches off the ground. The first street lamp was located on the corner of California Street and Broadway Avenue, it was installed by Judge O.H. Violet. James McCarthy sold the first dollar's worth of dry goods on commission and was the first traveling salesman in the city. The first banks were the Citizens' Bank and a faro bank operated by "Kid" Bannister. The first brothel was opened by "Big Anne" Wynn in a tent across the street from the railroad depot, where the first resident to step foot off the Santa Fe train, on April 22, 1889, was W.H. Ebey.

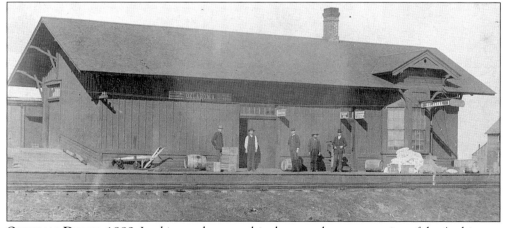

Original Depot, 1889. Looking to the west, this photograph presents a view of the Atchinson, Topeka & Santa Fe depot at Oklahoma Station. (John Dunning "Okie Archives.")

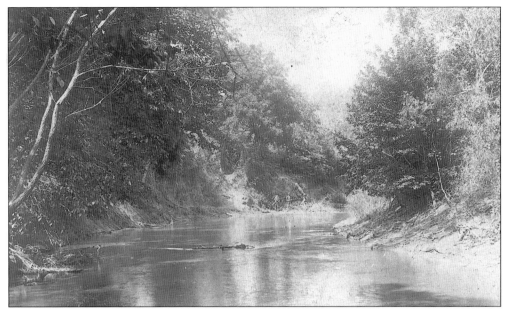

FISHING ALONG THE CANADIAN, 1889. This view was taken one half mile south of Oklahoma Station. The North Canadian River supplied pioneers with building materials and water. The back of this photograph reads: "Eve says paint this for her." (Archives & Manuscripts Division of OHS.)

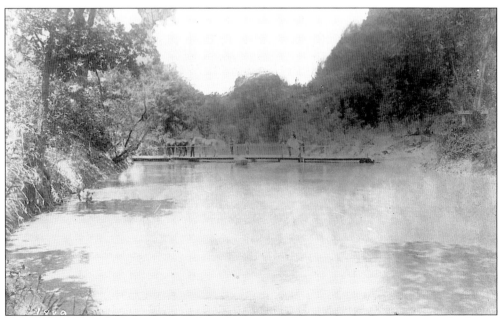

CROSSING THE BAR, 1889. Men and supplies are seen here crossing over a pontoon bridge on the North Canadian River, just east of the Santa Fe tracks. (Griffith Archives.)

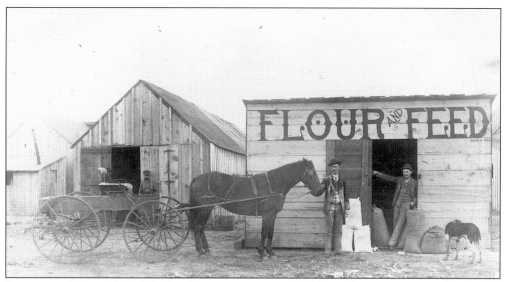

FLOUR AND FEED, 1889. The first business to open in Oklahoma Station was owned by farmer C.A. McNabb. The building to the left used a board-and-batten-style siding. (Archives & Manuscripts Division of the OHS.)

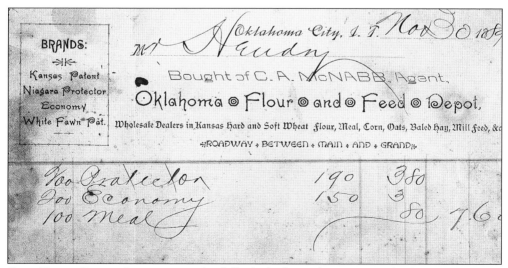

CASH POOR, CREDIT RICH, 1889. This bill of sale shows that 200 pounds of Niagra Protector lard, 200 pounds of Economy White Fawn flour, and 100 pounds of corn meal were purchased for $7.60. (John Dunning "Okie Archives.")

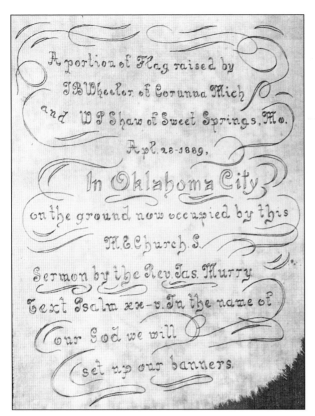

A portion of Flag raised by JB Wheeler of Corunna Mich and WP Shaw of Sweet Springs, Mo. Aprl. 28-1889, In Oklahoma City on the ground now occupied by this M.E. Church. S. Sermon by the Rev Jas. Murry Text Psalm xx—v. In the name of our God we will set up our banners.

RAISE THE BANNER, 1889. This is a portion of the flag raised by J.B. Wheeler & W.P. Shaw on the site of the M.E. Church, South, known today as St. Luke's United Methodist Church. (St. Lukes Museum & Archives, Oklahoma City.)

BALLOTS CAST, 1889. The first election was conducted May 24, 1889. Here voters cast their ballot at 107 West Main Street. (Sidney L. Stine Collection of the Archives & Manuscripts Division of the OHS.)

BUILD WITH BRICK. J.A. Hebble's brickyard supplied all of the brick for businesses during the first years of the city's growth. This photograph was taken one week after the "Run of 1889." (Drabek Collection of the Archives & Manuscripts Division of the OHS.)

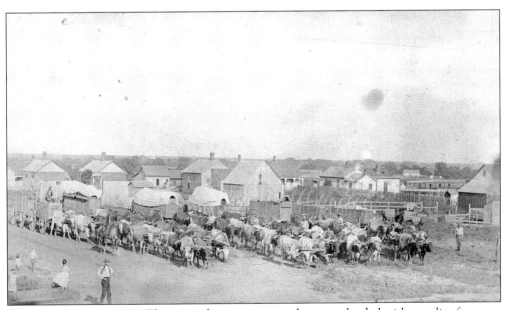

SUPPLIES ARRIVE, 1889. This view shows ten covered wagons loaded with supplies for eager merchants. The trees in the background suggest this photograph was not taken far from the North Canadian River. (Griffith Archives.)

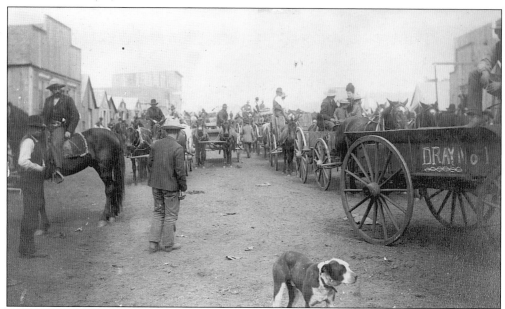

NAME CHANGES, 1889. Sometime from April 22 until May of the following year, several street names were changed. This scene shows traffic moving smoothly along Clark Street, which was later named Grand Avenue. (Griffith Archives.)

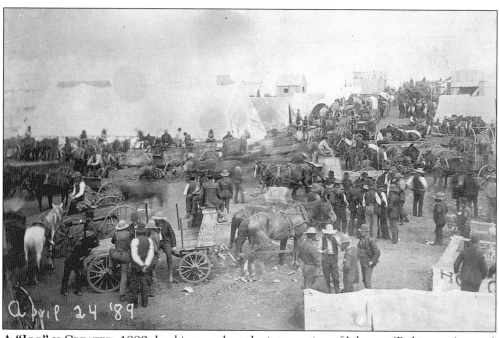

A "JOG" IS CREATED, 1889. Looking north at the intersection of Johnson (Robinson Avenue) and Clarke (Grand Avenue) Streets, this photograph shows street "jogs" that were created when opposing companies in the town refused to alter their survey alignments. This photograph was taken on April 24, 1889. (Griffith Archives.)

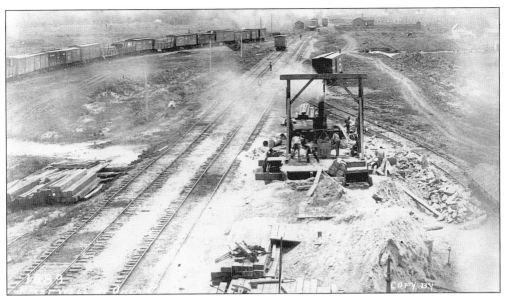

FIRST WELL, 1889. This Waterhouse and Terry photograph shows construction crews drilling the first public water well south of the railroad depot. (Griffith Archives.)

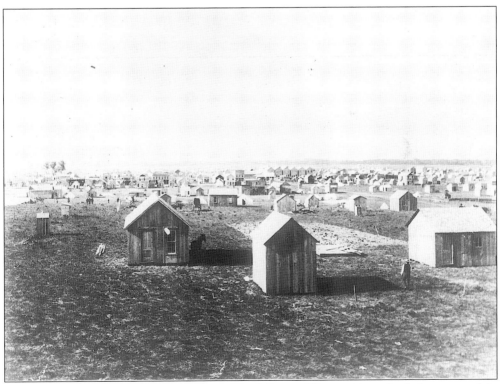

MAY 1889. This view looks south from Third Street. The trees on the left were used in the city's first accidental hanging. The six pre-fabricated buildings in the background were shipped by Henry Overholser prior to the Run. The Colcoed Building now occupies that site. (Griffith Archives.)

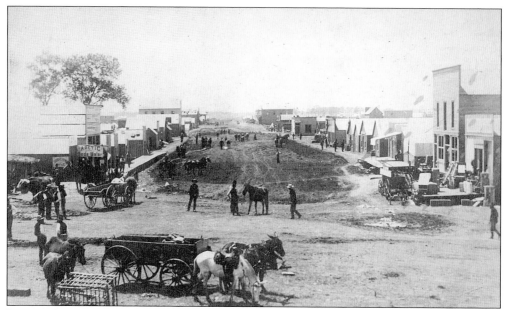

LITTLE GOMORRAH—THE RED LIGHT DISTRICT, 1889. Looking West from Front Street (Santa Fe), this view shows business as usual along Grand Avenue (Bunco Alley), but after sunset it was a different sort of business. The two-story building on the left was the Turf Saloon, owned by John Burgess, with the Southern Club a few doors to the west. Located at the intersection to the right of the photograph was Battle Row (Broadway Avenue), where the Venadome, owned by "Sportive Lizzie," and the Night & Day could be found next door to each other. (Griffith Archives.)

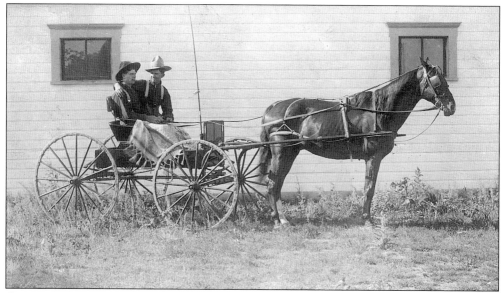

OH WHAT A NIGHT c. 1901. This postcard identifies these two friends only as R.C. and J.B. The photograph was taken along West Second Street, a.k.a. Harlots Lane, on the day after a wild night, and the words: "all nite at the Red Onion" say it all. The Red Onion was operated by Madam Clayton. (Griffith Archives.)

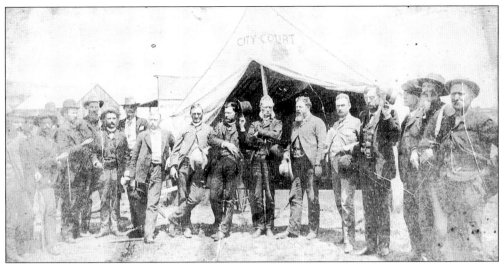

CITY COURT TENT, 1889. This photograph was taken at the southeast corner of California (Alabaster Row) and Broadway (Battle Row) Avenues. It shows the city's arbitration board on May 31, 1889. It is ironic that the city court sat in the middle of the red light district, with saloons and brothels as neighbors. (Griffith Archives.)

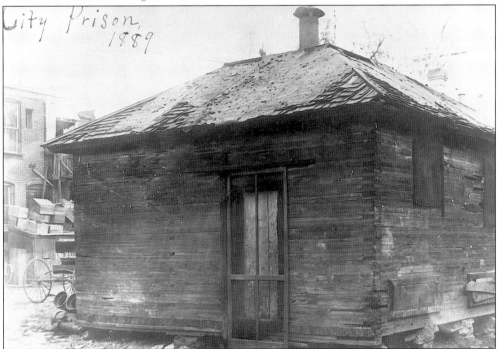

COTTONWOOD DE BASTILLE, 1889. Located between Grand Avenue and Main Street, this jail sat behind city hall on Broadway Avenue. On June 30, 1895, Chief Milton Jones and two officers stood at the corner of Broadway Avenue and Main Street while outlaw Jim Casey and the Christian Brothers overpowered a guard and escaped. Chief Jones went for his gun when Casey fired, hitting Jones in the throat only seconds before the other officers killed Casey. Jones was the first city lawman to give his life in the line of duty. (Archives & Manuscripts Division of the OHS.)

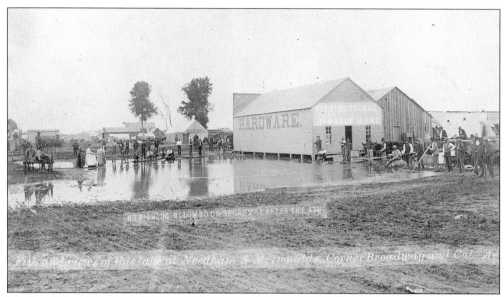

No Fishing After the Fourth. This scene shows citizens fishing along Broadway Avenue. The hardware store on the left advertised "Fishing Tackle Sold Here." The caption on the photograph reads: "Fish & Views of the lake." This photograph was taken by Needham & McDonalds, whose business was located on the corner of Broadway and California Avenues. (Griffith Archives.)

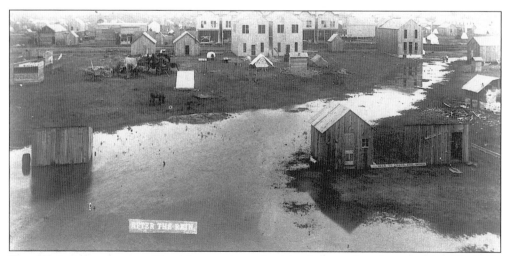

The Water Continues. The lake continues in this photograph, taken on May 22, 1889, showing additional flooding through downtown, which prompted city leaders to reroute the flow of the North Canadian River in 1890. (Griffith Archives.)

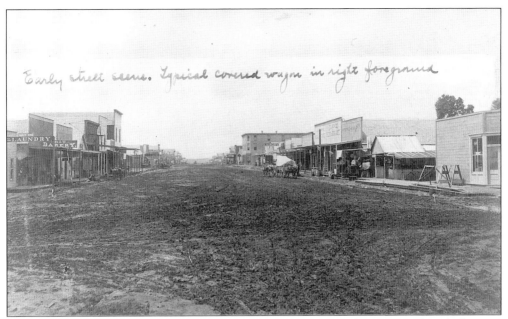

Early street scene. Typical covered wagon in right foreground

COVERED WAGONS. A sleepy city is seen here, looking west along an unidentified street. Delmonico's Restaurant is the fourth building on the left. (Griffith Archives.)

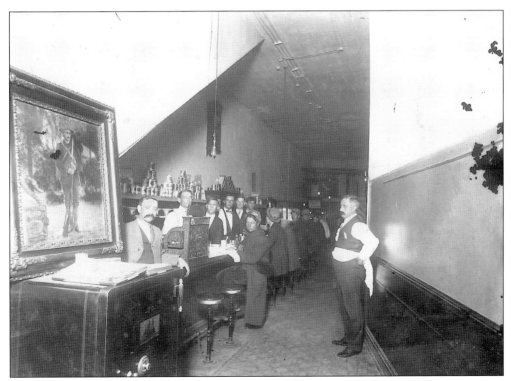

WHERE THE ELITE MEET TO EAT. An interior view of the famous Delmonico's Restaurant can be seen in this rare image. (Griffith Archives.)

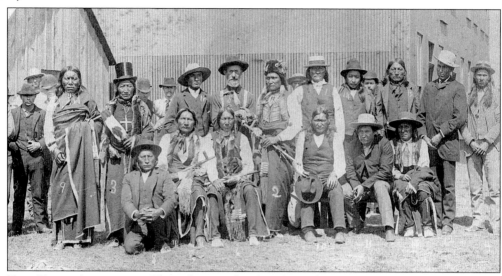

THE FIRST AMERICANS. This photograph identifies Cheyenne and Arapahoe chiefs at Oklahoma City, Indian Territory, from left to right, as follows: Little Bear (Cheyenne), Wolf Face (Cheyenne), Robert Burns (Cheyenne), John D. Mills, government official, Cut Nose (Arapahoe a), Row of Lodges (Arapahoe), Heap of Bear—son of Little Raven (Arapahoe), Starving Elk (Cheyenne), Leonard Tyler (Cheyenne), and Jack Bull Bear (Arapahoe); (seated) Wolf Rope (Cheyenne), Little Chief (Cheyenne), Cloud Chief (Cheyenne), Left Hand (Arapahoe), George Bent (Cheyenne), and White Eyed Antelope (Arapahoe). (John Dunning "Okie Archives.")*

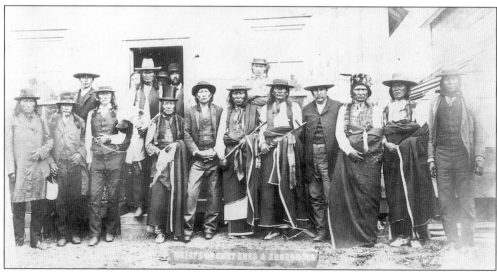

CHEYENNE AND ARAPAHOES, 1889. Taken by Waterhouse & Terry, this scene shows a meeting of the Cheyenne and Arapaho chiefs in regard to transferring land to the U.S. government for future land runs and land lotteries, at the post office building. From left to right the following are identified: Starving Elk (Cheyenne), Heap of Bear (Cheyenne), Robert Burns (Cheyenne), Row of Lodges (Arapahoe), an unidentified individual in the doorway with a hat, G.A. Beilder, postmaster, Wolf Face (Cheyenne), Wolf Rope (Cheyenne), Little Bear (Cheyenne), Jack Bull Bear (Arapahoe), Little Chief (Cheyenne), George Bent (Cheyenne), White Eyed Antelope (Arapahoe), and an unidentified individual. (Griffith Archives.)*

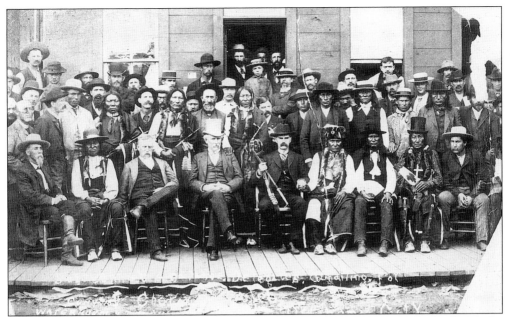

PEACE PIPES AND PEACE TREATIES. This Waterhouse & Terry photograph shows the entire congregation of U.S. government officials as well as Cheyenne and Arapaho chiefs. (Griffith Archives.)

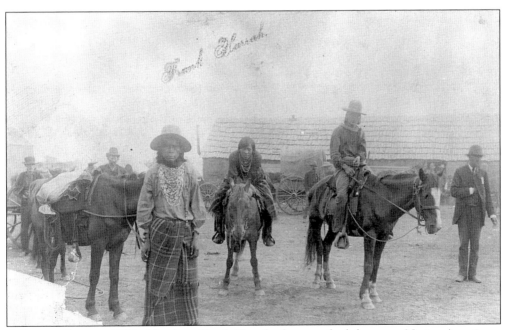

A PROUD PEOPLE, 1889. Merchant Frank Harrah photographed these two Native Americans on California Street on May 5, 1889. (Frank Harrah Collection of the Archives & Manuscripts Division of the OHS.)

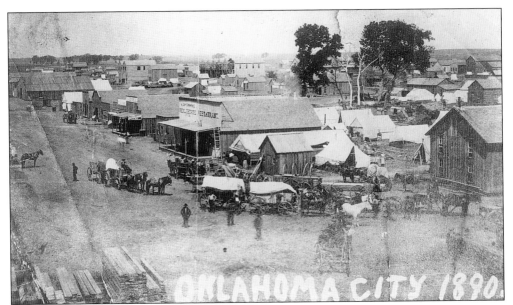

RENO AVENUE AND FRONT STREET. This scene shows the daily activity in Oklahoma City. Sherman's Restaurant can be seen on the right. (Griffith Archives.)

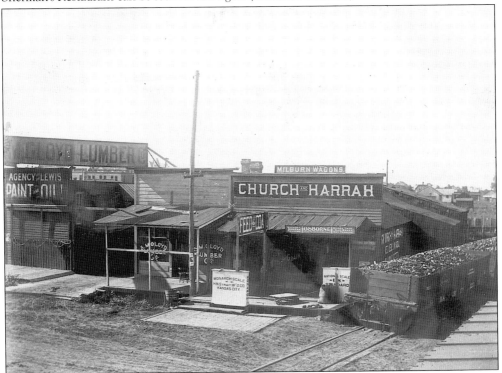

CHURCH AND HARRAH. W.O. Church made the Run and opened a small cafe in a tent. Frank Harrah arrived a few hours later, tossed his carpetbag under the station platform, and smelled coffee brewing. Discovering the cafe, he asked Church if he needed help. Church told Harrah to put on an apron, and the rest, as they say, is history. (Archives & Manuscripts Division of OHS.)

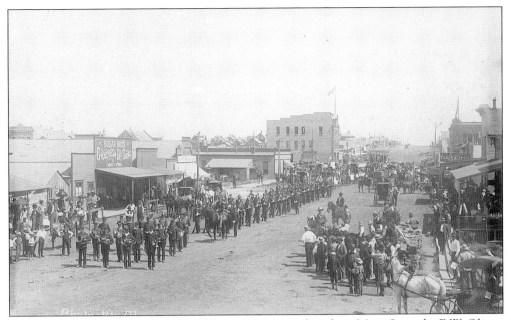

FIFTEEN MONTHS AFTER OPENING. This picture was taken from Main Street by E.W. Oliver, along North Broadway Avenue, during a Fourth of July parade. The large four-story building is the new post office, which was completed July 1, 1890. (Griffith Archives.)

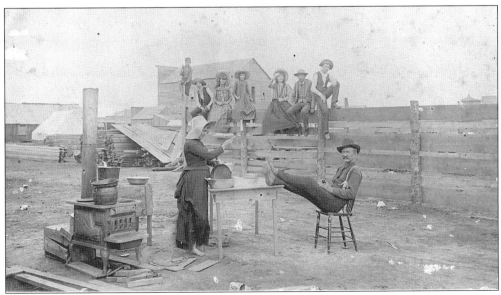

PRIORITIES IN 1889. A man may work from sun to sun, but a woman's work is never done. (Griffith Archives.)*

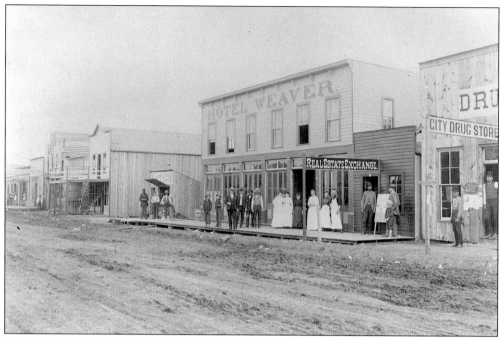

MAY 1889. Mrs. M.A. McGee operated the Hotel Weaver, which was located on Main Street between Broadway and Robinson Avenues. The Weaver ceased operations by 1903 at which time Mr. J.W. Hehlt was owner of the City Drug Store. (Nadine Pendleton Collection of the Archives & Manuscripts Division of OHS.)

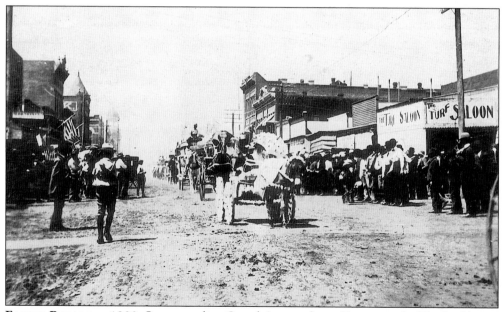

EASTER PARADE c. 1900. Spectators line Grand Avenue for an Easter parade. The lead buggy is decorated with white mums, and the following close-up of photographs shows how much care and attention was given by each participant. (Heaney Collection of the Harn Homestead & 1889er Museum, Oklahoma City.)

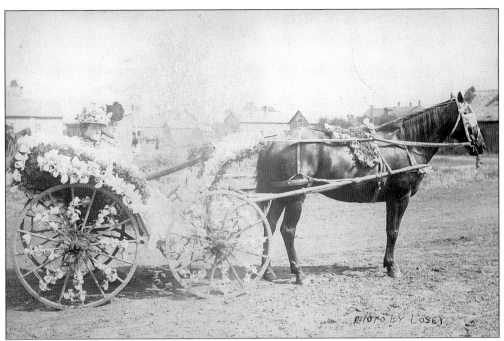

PHOTOGRAPH BY LOSEY c. 1900. These two ladies had the same idea when they decorated their carriages for the Easter parade. (Heaney Collection of the Harn Homestead & 1889er Museum.)*

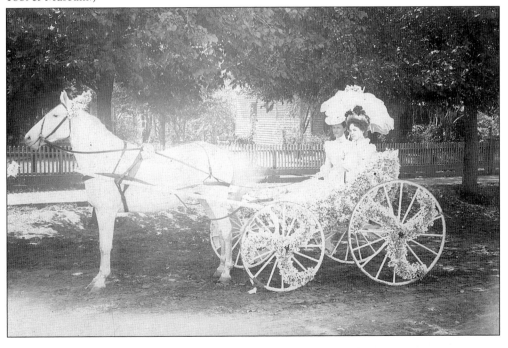

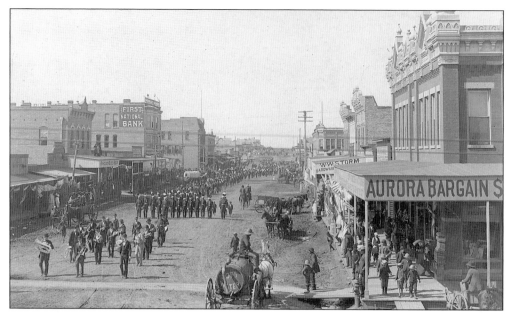

PARADE SCENE, 1893. This view looks east from the Aurora Bargin Store located at 2–4 North Broadway Avenue (Mose Herkowitz, proprietor). The next visible business is W.W. Storm Hardware, while on the left midway up the street is the First National Building with the post office in the distance. (Griffith Archives.)

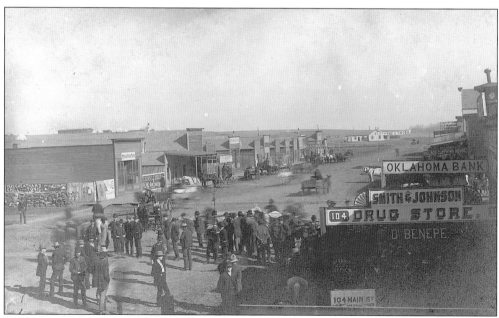

RUSH HOUR, 1895. Fred Dalton had this picture taken with his hands in his pockets. He is the one located directly above his name in the caption. This view of Main Street and Broadway Avenue is looking east towards the old Military Reservation. (Griffith Archives.)

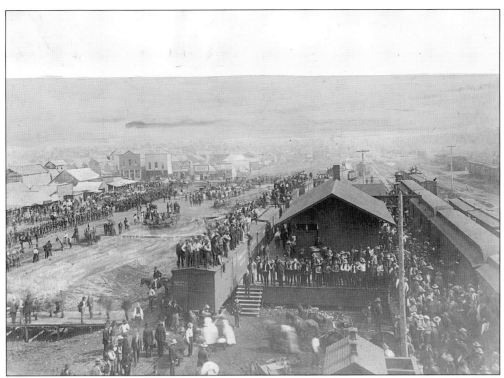

JULY 1889. A large crowd is seen gathered at the Santa Fe depot preparing for a Fourth of July parade. (Griffith Archives.)

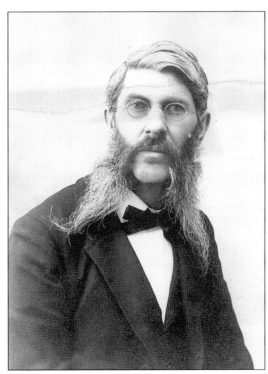

E.W. OLIVER, 1889. One of the most prominent territorial photographers, E.W. Oliver and his wife, Mary, operated their small studio at 129 1/2 West Main Street. (Heaney Collection of the Harn Homestead & 1889er Museum.)*

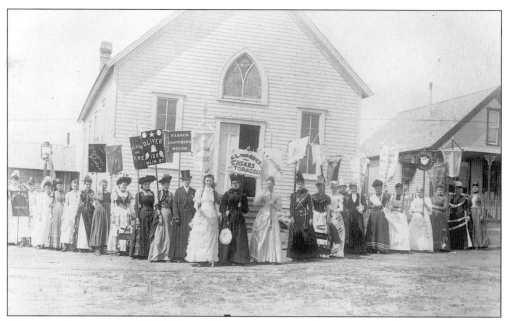

WALKING BILLBOARDS, 1890. These ladies are carrying advertisements for various businesses in Oklahoma City. This photograph, taken by E.W Oliver, shows them standing in front of the First Methodist Episcopal Church, North. (Alvin Rucker Collection of the Archives & Manuscripts Division of OHS.)

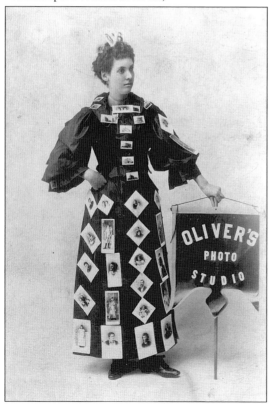

A CLOSE UP, 1890. Oliver's Photograph Studio's human billboard is shown here ready for the line up. The model is his wife Mary. (Heaney Collection of the Harn Homestead & 1889er Museum.)

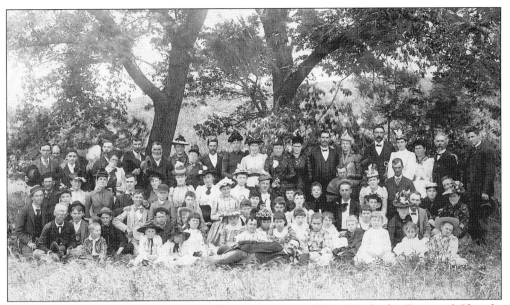

FIRST M.E. CHURCH, NORTH, 1890. The congregation of First Methodist Episcopal Church, North, spends a leisurely afternoon picnicking at Wheeler Park. This photograph shows the charter members of First Church. (Florence Wilson Collection of the Harn Homestead & 1889er Museum.)

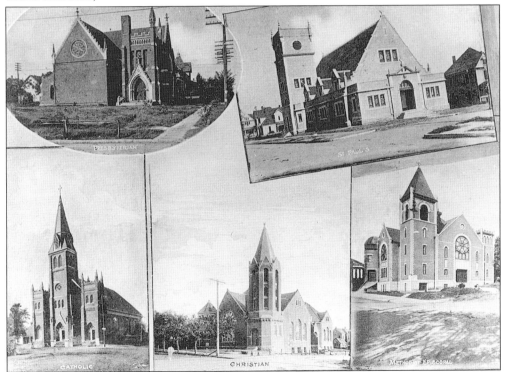

CHURCHES OF 1889. The city's first churches, from left to right, are as follows: First Presbyterian, St. Paul's Episcopal Cathedral, St. Joseph's Catholic Cathedral, First Christian, and Methodist Episcopal Church, North. (John Dunning "Okie Archives.")*

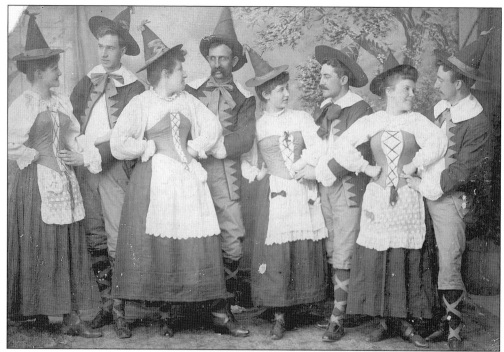

THE TYROLEAN DANCE, 1892. *Kirmess,* a play directed by Miss Grace Richardson and sponsored by the St. Paul's Guild (Episcopal), was performed in the old Overholser Opera House on February 10th and 11th. From left to right are as follows: Jess Williams, Lyman Allen, Mabel Nouson, Willie Clark, Mae Nathan, George Smeltzer, Flora Jarboe, and D.P. Mason. (Griffith Archives.)

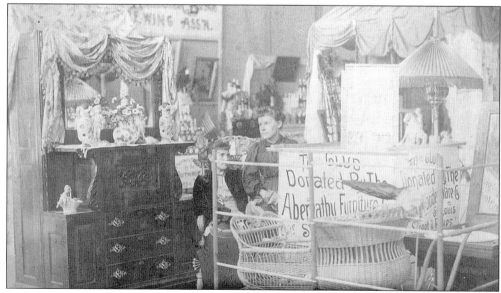

EARLY BAZAAR. The sign, which reads, "To the Club," was donated by the Abernathy Furniture Co., St. Louis. Seated in this photograph are Jess Williams and Flora Jarboe, who are helping to raise money for the thespian club at the Overholser Opera House. The photograph reads, "Your choice for $1.00." (Griffith Archives.)*

34

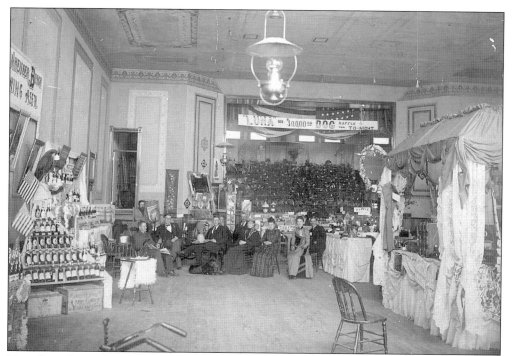

THE OLD OVERHOLSER, c. 1894. E.W. Oliver photographed this interior view of the first Overholser Opera House, on Grand Avenue, which was being used for a charity bazaar. Mrs. Overholser's booth is seen on the right. Seated from left to right are as follows: Ben Miller (an Army officer), Ledre Guthrie, Ralph Githrie, Mrs. Nettie Wheeler Chapell, Mrs. Ben Miller, and Mrs. Henry Overholser. (Overholser Mansion Collection of OHS.)

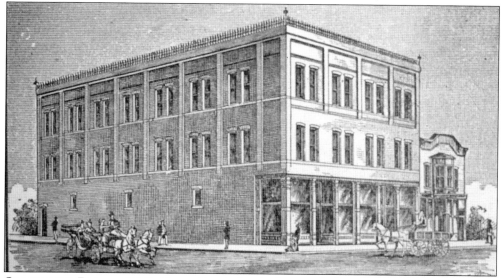

OVERHOLSER BLOCK, 1890. Henry Overholser built a total of 11 buildings at a cost of over $100,000. Used by the federal government as a courthouse, this three-story building and basement structure had a frontage of 50 feet on Grand Avenue and 100 feet on Robinson Avenue. The brick and stone Overholser Block stood on the northeast corner of Grand and Robinson Avenues. (Griffith Archives.)

REVEREND A.W. RAY, 1898–1900. The fifth minister to preach from the pulpit for the 182-member congregation of the M.E. Church, South, Reverend Ray had a salary of $900 per year. (St. Luke's Museum & Archives, Oklahoma City.)*

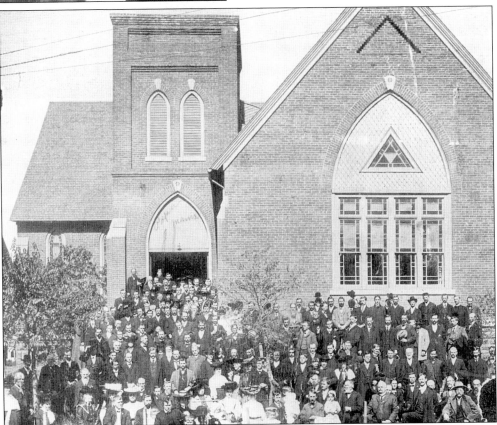

FIRST M.E. CHURCH, SOUTH, 1890. The charter members of the M.E. Church, South, gathered in front of their new brick structure. The church is known today as St. Luke's United Methodist Church. (St. Luke's Museum & Archives.)

ALPHA AND OMEGA. Shown here are the first and last pages of Reverend Ray's sermon that he delivered on July 6, 1899. When delivering his inspiring sermons, he did so without his notes. (St. Luke's Museum & Archives.)*

PLAYING FOR OKLAHOMA CITY, c. 1897–1900. These young teens made up the entire football team of the Oklahoma City High School. the players, shown from left to right, are as follows: (kneeling) George Markwell and Dave McClure; (standing) Ed Carter and Jesse Garrett. (Archives & Manuscripts Division of OHS.)*

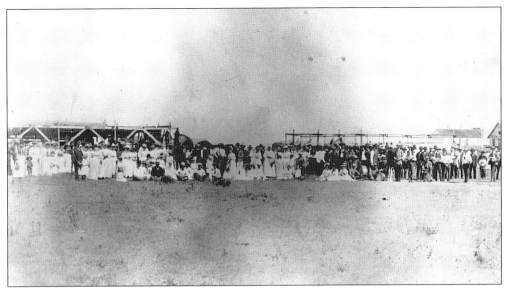

TAKE ME OUT TO THE BALL GAME, 1889. This photograph of a crowd at a baseball game on the grounds of the military reservation was taken during the summer of 1889. (Lollar Collection of the Archives & Manuscripts Division of OHS.)

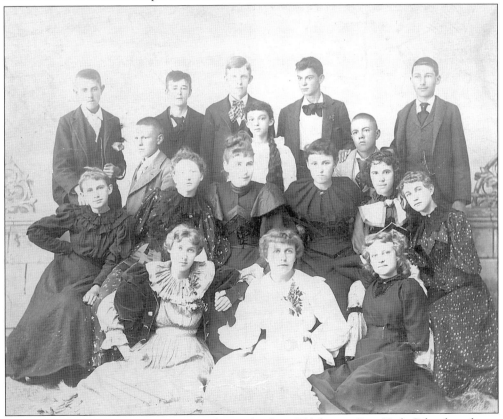

THE FIRST CLASS. This nice portrait shows the first Oklahoma City High School students. (Heaney Collection of the Harn Homestead & 1889er Museum.)*

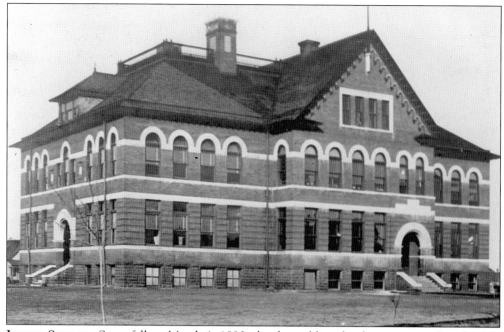

IRVING SCHOOL. Snow fell on March 1, 1890, the day public schools were opened, and 1,000 children marched around town when school was dismissed. This high school was completed in time for the opening of class in September 1896. (Griffith Archives.)

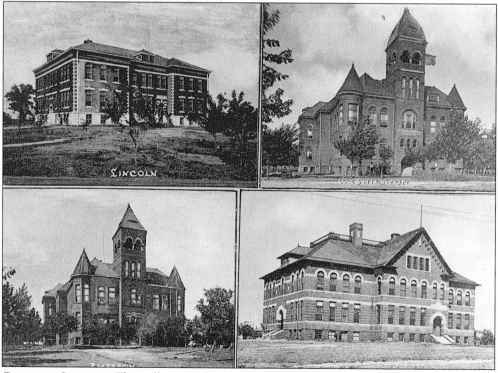

GROUP OF SCHOOLS. This collection of public schools, from left to right, is as follows: Lincoln, Washington, Emmerson, and Irving. (John Dunning "Okie Archives".)

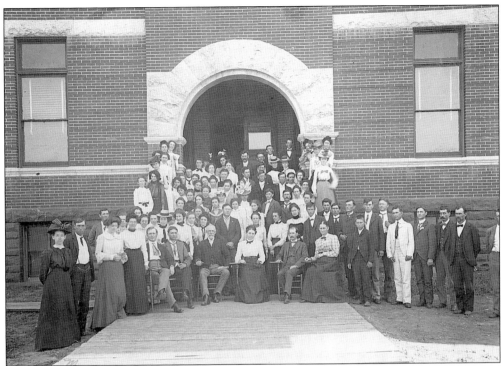

TEACHER'S INSTITUTE, 1896. The Marcellus Art Studio photographed this image of the 1896 Oklahoma County Teachers Institute in Oklahoma City. (Heaney Collection of the Harn Homestead & 1889er Museum.)*

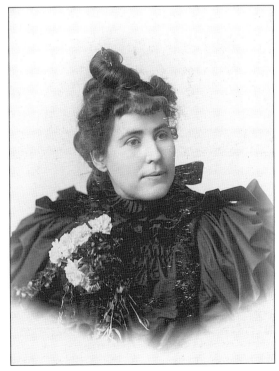

MISS ALICE BEITMEN, 1896. This Hamilton photograph is of Oklahoma County superintendent of schools, Miss Alice Beitmen. (Heaney Collection of the Harn Homestead & 1889er Museum.)*

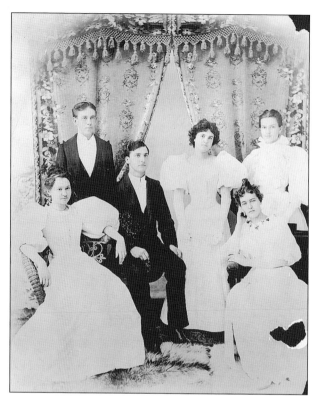

FIRST HIGH SCHOOL, c. 1890.
This photograph was taken of Mrs.
Alice Beitman Heaney's students
in the first graduating class of
Oklahoma City High School. Mrs.
Selwyn Douglas was the principal
at that time. (Alice Beitman
Heaney Collection of the Harn
Homestead & 1889er Museum.)

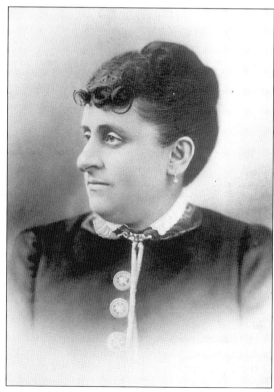

MRS. SELWYN DOUGLAS, 1898.
Mrs. Douglas was an early day school
teacher, cultural leader, president of the
Philomathea Club, and chairman of
the Public Library Association. (Harn
Homestead & 1889er Museum.)*

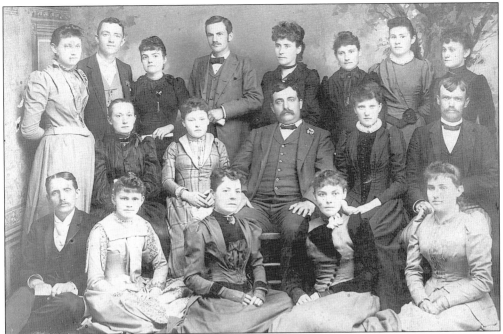

BOARD OF ADMINISTRATION. The hand-written list, found on the back of the image, does not identify all these individuals nor does it give a clue as to the order of names. The names read as follows: Ruby Bailey, Ed Scott, Cal Leach, Alice V. Beitmen, Celene Gray, Daisy Jones, Nina Johnson, Mrs. Bainum, Minnie Nix, R.A. Sullivan, Eshel Walker Adamson, Rella Harbour, Flowers and Belle Hendry. (Heaney Collection of the Harn Homestead & 1889er Museum.)*

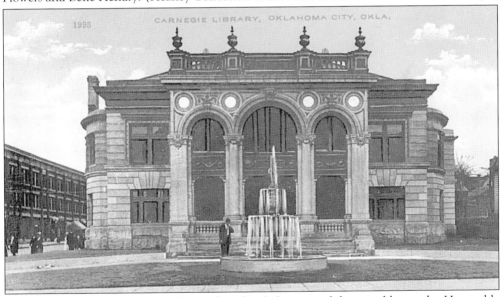

CARNEGIE, 1900. In a speech delivered at the dedication of the new library, the Honorable A.H. Classen, president of the Commercial Club said, "In getting this donation of $25,000 to build this edifice from Mr. Carnegie, the Philomathea Club and Mrs. Selwyn Douglas, president of the library association, has successfully carried out the plan to achieve this new building." The library was designed by Marshall R. Sanguinot of Fort Worth, Texas. (Griffith Archives.)

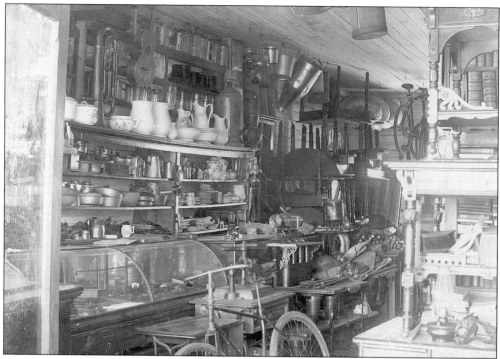

DRY GOODS, 1895. Shown here is a view of Schweinle & Monroney Dry Goods, 8-10 West Grand Avenue, which had everything a person might need. W.J. Schweinle and A.E. Monroney changed the name of their store to Doc & Bill's around 1903. (Griffith Archives.)

"AS HIGH AS AN ELEPHANTS EYE." Corn proved to be a cash crop for farmers in the new territory. This photograph shows a good harvest as 1898 ushered in the "golden age" of agriculture. (John Dunning "Okie Archives.")

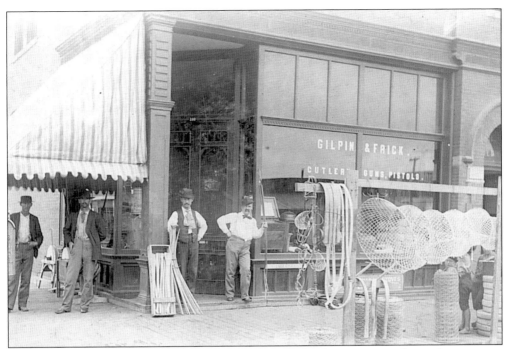

GILPIN AND FRICK. C.F. Gilpin and A.L. Frick opened a hardware store on the southeast corner of California and Broadway Avenues, shortly after they arrived in Oklahoma Station in 1889. The hardware store was closed by the time of statehood. (Griffith Archives.)*

HARRY BACON. Standing on the future site of the Baptist White Temple, the photographer looks toward Fourth Street and Broadway Avenue. Harry was the chairman of the county commissioners. (John Dunning "Okie Archives.")*

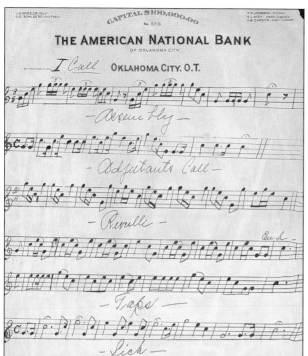

BANK NOTES. A bank employee has written out bugle calls on this bank stationary. (The Johnson-Hightower Family Collection, Oklahoma City.)*

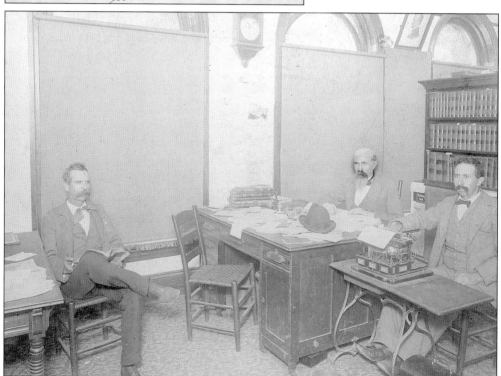

MILTON AND STEWARD. Pictured here, from left to right, are N.M.S., Judge Milton, and Judge Steward at their offices located at California and Broadway Avenues. (Harn Homestead & 1889er Museum.)*

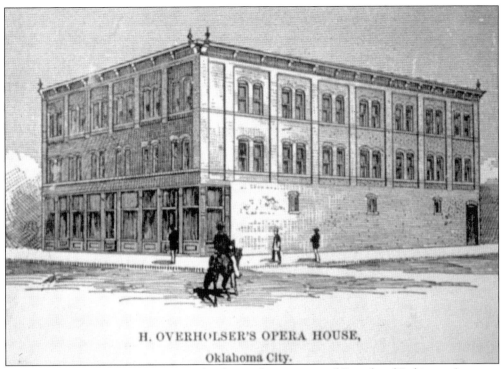

H. OVERHOLSER'S OPERA HOUSE,
Oklahoma City.

OVERHOLSER OPERA HOUSE, 1890. On the southeast corner of Grand and Robinson Avenues, the opera house could easily seat 1,000 people. Used in the early years for bake sales, dances, and political rallies, about the only group not allowed to rent the hall were the democrats. Mr. Overholser was a republican. (Griffith Archives.)

FATHER OF OKLAHOMA CITY. When Henry Overholser met his son Ed at the depot, they looked over the vast layout of the growing city. Henry told his son that every new city needs theaters, hotels, schools, and churches. "I think we'll build the theaters and hotels and let someone else build the schools and churches." Conversations containing these imaginary words could very well have been spoken as the two Overholsers went on to build for the economic success of Oklahoma City. (Overholser Mansion of OHS.)

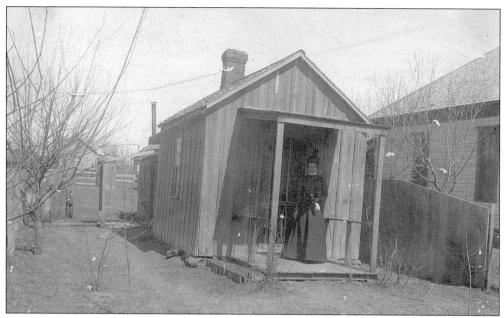

HOME BUILT IN 1889. With a shortage of lumber in the creation of Oklahoma City, people made due with what was available. This homemaker was proud enough to have her picture taken on the front porch of her home. (Harn Homestead & 1889er Museum.)*

PICKING COTTON. Workers in the field picked cotton in the hot sun. The cotton would be taken to the Oklahoma Cotton Compress Company in Oklahoma City and then shipped to markets in Tulsa, Kansas City, and St. Louis. In 1897, cotton sold for 11¢ a pound. (John Dunning "Okie Archives.")

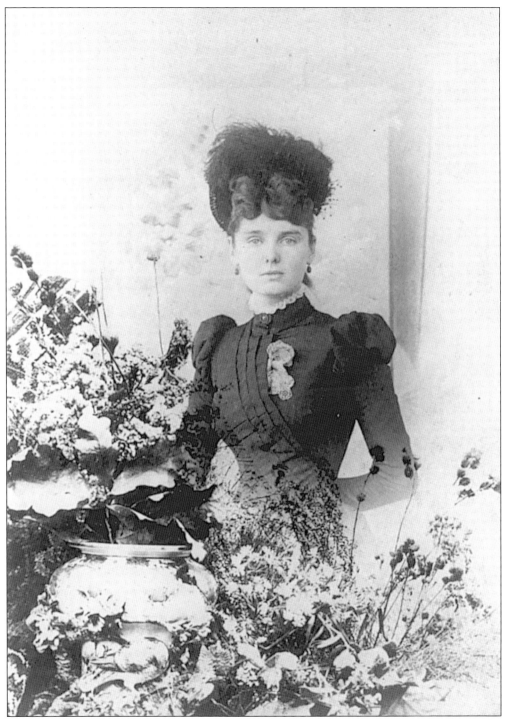

ANNA IONE (MURPHY) OVERHOLSER. Anna arrived in Oklahoma City in June of 1889, at the age of 18. Within two months she married the 43-year-old capitalist, Henry Overholser. The young Anna Ione Overholser became the hub of society for Oklahoma City until her death in 1940. (Overholser Mansion of the OHS.)

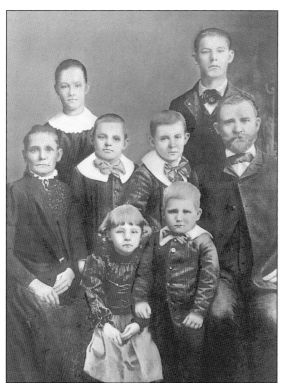

HANSON FAMILY. The Hansons made the Run of 1889. August was 15 when the family came to Oklahoma Station and all but Mr. Hanson are buried in Fairlawn Cemetery. Left to right, (front row) Alice Hanson Witcher, youngest daughter; and Ray Andrew, youngest son; (middle row) Mrs. Mary Katherine Hanson (1848–1918); Edward, second son; and Henry Foster, third son; and Mr. Andrew Hanson (1841–1893), who is buried in Larned, KS; (back row) Emily Josephine Hanson, oldest daughter; and August Severin Hanson, oldest son (1874–1918).*

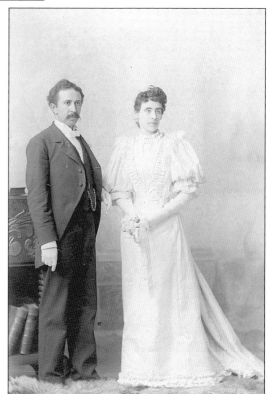

THE STEWARD FAMILY. This photograph is the wedding portrait of Judge Seymour and Mrs. Steward on June 7, 1893, taken in Joliet, IL. The Stewards moved to Oklahoma City the same year. (Harn Homestead & 1889er Museum.)*

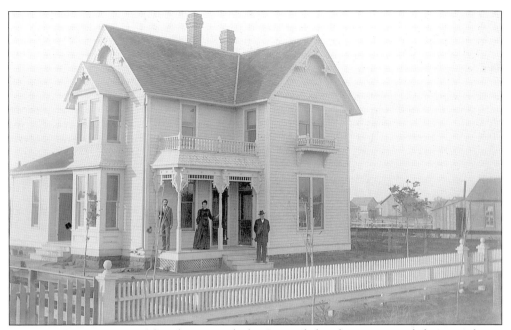

STEWARD HOME, 1893. After their arrival, the Stewards lived in town until their new home was completed at 212 West Chickasaw (which later became Fifth) Street in South Oklahoma City. This photograph by E.W. Oliver shows Judge and Mrs. Steward on their front porch with an unidentified man. (Harn Homestead & 1889er Museum.)*

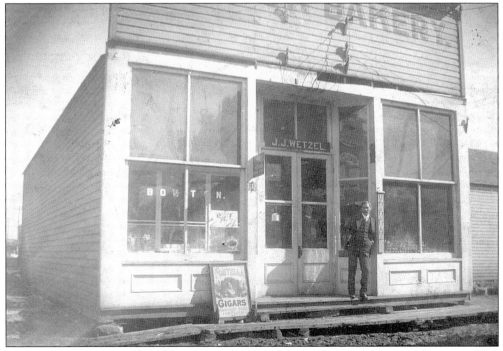

MOVING SALE, 1900. J.J. Wetzel was listed as "capitalist" in the city directory. This photograph shows the Bon Ton Bakery being moved while business carried on inside. (Griffith Archives.)*

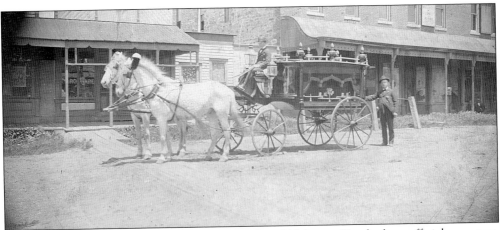

THE FIRST CEMETERY. It was not until 1891 that Oklahoma City had an official cemetery, which would be known as Fairlawn. This photograph shows two undertakers with livery and rolling stock. (Griffith Archives.)*

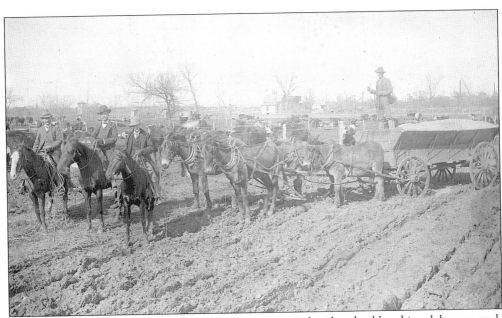

FARMING. Clearing land of sod and stumps required either backbreaking labor or cash to have the work hired out. The hardships of the 1890s forced most frontier families of Oklahoma County to be self-sufficient. When neighbors could help out they did. This Losey Studio photograph shows these men on their way to the market in Oklahoma City. (Griffith Archives.)*

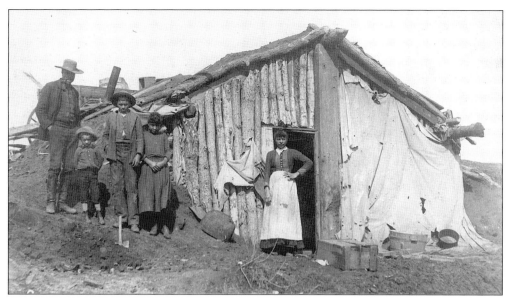

HALF AND HALF, 1891. This low-lying structure is half frame house and half dugout. Note that the home is built into a hill, probably to help provide shelter from the north wind. Many families stayed in these "first homes" until they were certain times could afford otherwise. (Archives & Manuscripts Division of OHS.)

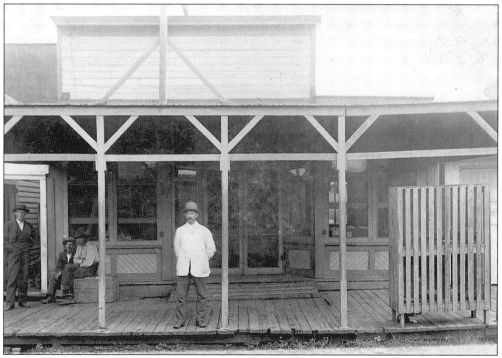

STAR MEAT MARKET. Operated by Isaac and Johanna Loewenstein, who made the Run of 1889 from New York City, the market provided fresh and salted meats. This photograph shows Isaac in front of the store, located at 111–113 West Grand Avenue. (Morris Loewenstein Collection of the Harn Homestead & 1889er Museum.)*

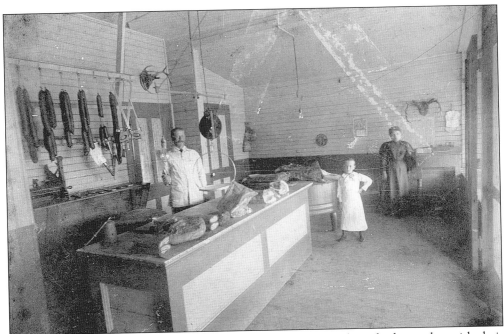

THE LOEWENSTEIN FAMILY. The Loewenstein family is pictured inside the market with their son, Morris, who is about six years old. (Morris Loewenstein Collection of the Harn Homestead & 1889er Museum.)*

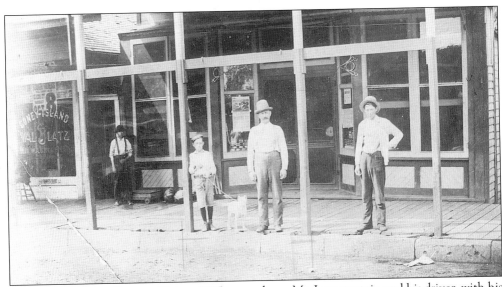

THE LOEWENSTEIN FAMILY. This c. 1895 scene shows Mr. Loewenstein and his driver, with his son Morris and his dog Roy on the left. (Morris Loewenstein Collection of the Harn Homestead & 1889er Museum.)*

GROCERY RECEIPT. This receipt shows an order for 23 breaded cutlets, 24 oysters, 25 steaks, and eggs for $1.45. By 1902, the Loewenstein's retired and, in 1906, Morris worked as an advertising agent for Delmar Gardens. (Morris Loewenstein Collection of the Harn Homestead & 1889er Museum.)*

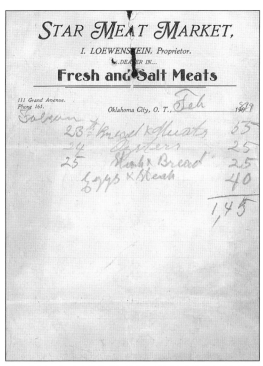

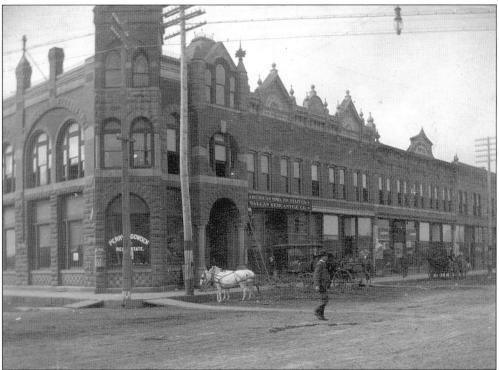

THE PREMIER HOTEL. When Henry Overholser built the Grand, he wanted to ensure that the guests staying there would have a pleasurable experience. Every room had electric lights and an adjoining sitting room. (Overholser Collection of the OHS.)*

STONE HOME, 1889. L.B. Stone made the run with ready cash, enough to build this fine residence for his wife Josephine. This photograph shows family members with setters in the front yard. (Griffith Archives.)*

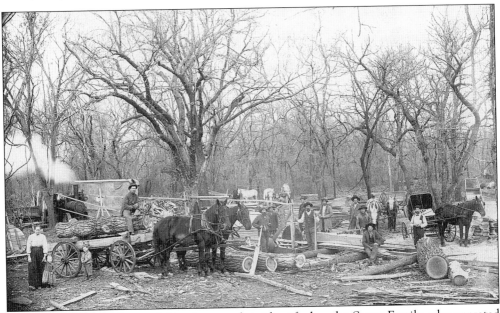

STONE FARM. The subject of this photograph is identified as the Stone Family, who operated a sawmill at the south edge of their property. Mr. Stone is on the wagon. (Henrietta White Collection of the Harn Homestead & 1889er Museum.)*

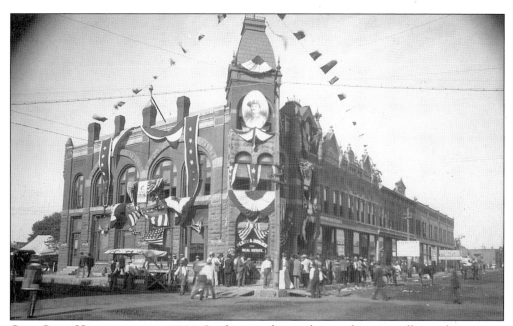

CITY CLUB HEADQUARTERS, 1900. Looking to the southwest, this view offers a glimpse into the preparations for the Rough Riders National Convention. The decorated building is the Farmers National Bank, and to the left is the Grand Avenue Hotel. Note the photograph of Roosevelt on the bank building. (Griffith Archives.)*

ROUGH RIDERS CONVENTION, 1900. New York governor Theodore Roosevelt was Oklahoma City's guest of honor at the national reunion of the Rough Riders. During a speech at the fair grounds, he yelled to the spectators, "Men and Women of Oklahoma. I was never in your country until last night, but I feel at home here. I am blood of your blood, and bone of your bone, and I am bound to some of you, and to your sons, by the strongest ties that can bind one man to another." (John Dunning "Okie Archives.")*

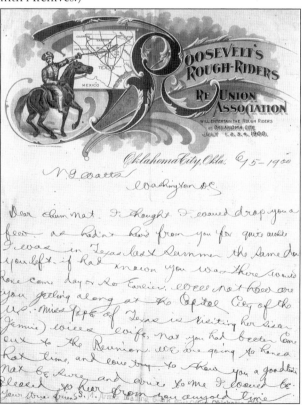

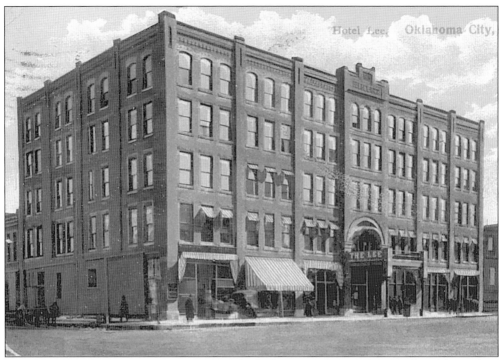

THE BUILDING BOOM, 1900. Oscar G. Lee built this magnificent 150-room hotel located on the southeast corner of Main Street and Broadway Avenue. This five-story, $100,000 palace contained the city's first electric elevator. "Buffalo Bill" Cody was a guest here, as was Roosevelt, who stayed during the Rough Riders Convention in 1900. (Griffith Archives.)

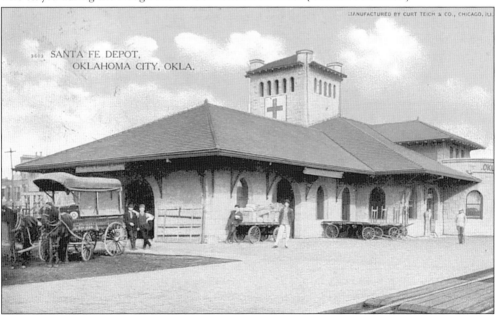

THE SECOND SANTA FE, 1900. Constructed just west of the first wooden structure, the second depot was designed in the Richardson Romanesque style. This stone depot was razed in 1930. (Griffith Archives.)

MR. WILLIAM FREMONT HARN. As special agent for the Department of the Interior, Harn opened a third land office in Oklahoma City in 1891. The other two were in Guthrie and Kingfisher. Harn had two objectives: to help the Boomers with their claim disputes and to seek out and prosecute the Sooners for perjury. (Harn Homestead & 1889er Collection.)

GOVERNMENT NO FRILLS POSTCARDS. The first postcard to feature a photograph in Oklahoma City was produced in 1901. Until then, postcards were government controlled, like the one pictured here. It reads, "I have a case Parker v. Horn and Vance which is set for trial in Land Office on 19th and it may be I can not leave this district. If so, I desire you to conduct the trial. Let me know at once if you will be sure to be there. Will not take more than one day. What will be your fee?" (Harn Homestead & 1889er Museum.)*

MARY E. MCCLURE. Widow of John McClure, Mrs. McClure roomed at 801 North Broadway Avenue and never remarried. Note the Eastern Star badge pinned at her throat. (Harn Homestead & 1889er Museum.)*

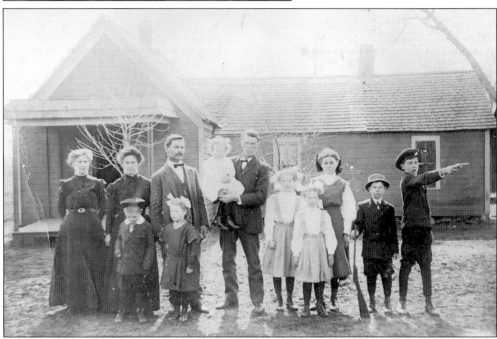

FAMILY GATHERING. Family members identified in this 1899 photograph are, from left to right, as follows: Clara J. Penny, Temperance Ann Ross, David A. Ross, Everett C. Penny, Luch J. Classen, Nancy Chamberland Ross, Sam Ross, and Clarence Penny. The children in front are Charles E. Penny, Nellie Ross (Remington), Viola Mae Penny (Robertson), and Tempie Penny (Kemper). The present location of this home is near Southeast 104th Street. (John Dunning "Okie Archives.")*

ANTON CLASSEN. After landing in Edmond during the 1889 Land Run, Anton Classen moved to Oklahoma City in 1897, where he was elected president of the Commercial Club (chamber of commerce) in 1899. He became involved in real-estate development, transportation, and a savings and loan association. (Archives & Manuscripts Division of OHS.)

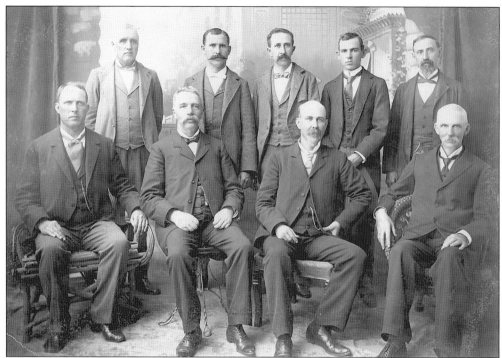

BOARD OF TRUSTEES, 1900. Beginning in 1893, the St. Louis & Oklahoma City Railroad insured growth and commerce to Oklahoma City. The line was purchased by the St. Louis & San Francisco (Frisco) Railroad in 1897. The members of the board are shown here, from left to right, as follows: (bottom row) C.G. "Gristmill" Jones, Henry Wills, T.M. Richardson, and Judge Sidney Clark; (top row) Henry Overholser, J.M. Owen, Judge S.A. Steward, F.L. Dobbin, and F.M. Riley. (Griffith Archives.)

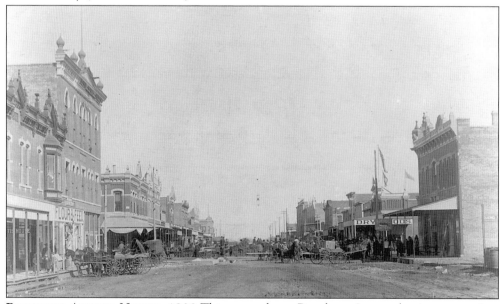

BROADWAY AVENUE NORTH, 1900. This scene shows Broadway Avenue having sewer pipes installed. (Griffith Archives.)*

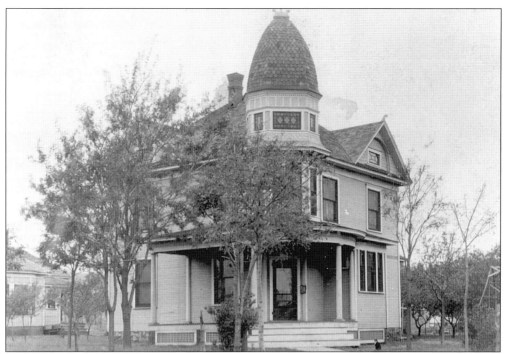

HOME OF G.A. BEIDLER, 1900. In 1903, the G.A. Beidler family moved into this Victorian home built in 1900. At that time, this house was on the last street on the north side of town at 601 North Seventh Street. (John Dunning "Okie Archives.")

HOME OF G.A. BEIDLER, 1970. After Mr. Beidler's death, his daughter, Bernice, continued to live in the home for about 65 years. The home was razed in the mid-1970s. (John Dunning "Okie Archives.")*

(4—404.)

THE UNITED STATES OF AMERICA,

To all to whom these presents shall come, Greeting:

Homestead Certificate No. 2059

APPLICATION 187

Whereas There has been deposited in the General Land Office of the United States a Certificate of the Register of the Land Office at *Oklahoma, Oklahoma Territory*, whereby it appears that, pursuant to the Act of Congress approved 20th May, 1862, "To secure Homesteads to actual Settlers on the Public Domain," and the acts supplemental thereto, the claim of *John A. J. Bauguess* has been established and duly consummated, in conformity to law, for *Lots numbered four, five, six and seven of Section five, Township eleven North, of Range three West of Indian Meridian in Oklahoma Territory, containing one hundred and twenty seven acres, and eighty seven hundredths of an acre* according to the Official Plat of the survey of the said Land, returned to the General Land Office by the Surveyor General:

Now know ye, That there is, therefore, granted by the United States unto the said *John A. J. Bauguess* the tract of Land above described: TO HAVE AND TO HOLD the said tract of Land, with the appurtenances thereof, unto the said *John A. J. Bauguess* and to His heirs and assigns forever.

In testimony whereof, I, *Grover Cleveland*, President of the United States of America, have caused these letters to be made Patent, and the Seal of the General Land Office to be hereunto affixed.

Given under my hand, at the City of Washington, the *seventeenth* day of *June*, in the year of our Lord one thousand eight hundred and *ninety six*, and of the Independence of the United States the one hundred and *twentieth*.

BY THE PRESIDENT: *Grover Cleveland*

By *M. McKean*, Secretary

L. Q. C. Lamar, Recorder of the General Land Office

Recorded, Vol. 5, Page 116.

HOMESTEAD CERTIFICATE, 1896. John A.J. Bauguess was issued title Number 2059 to lots 4, 5, 6, and 7 of Section 5, Township 11 North, Range 3 West, of the Indian Meridian, O.T., containing 127 and $^{87}/_{100}$ acres. (Harn Homestead & 1889er Collection.)*

MOTHER AND CHILD, 1891.
This E.W. Oliver photograph shows Mrs. Helen Friday Condon with her infant. Her husband, Webster B., was a carpenter and they made their residence at Fourth Street and Broadway Avenue. By 1903, Mr. Condon was a lumber dealer and the family lived at 616 East Seventh Street. There is no mention of the baby in any city directory. (Heaney Collection of the Harn Homestead & 1889er Museum.)*

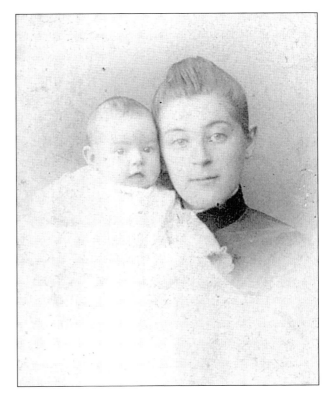

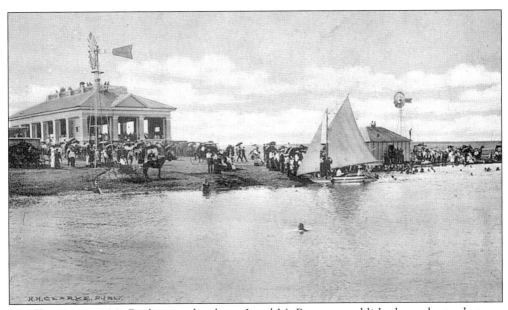

I.M. PUTNAM, 1900. Real estate developer Israel M. Putnam established a park at, what was then, the north end of the interurban line. (Griffith Archives.)

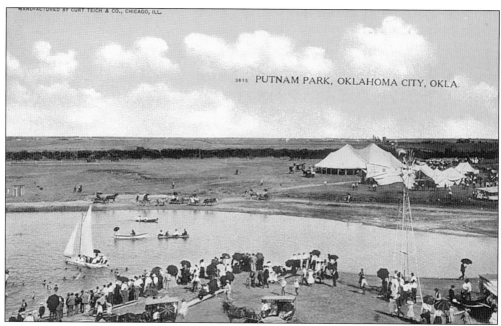

3615 PUTNAM PARK, OKLAHOMA CITY, OKLA.

LAZY DAYS OF SUMMER, 1900. Putnam Park was enjoyed by many residents during the hot summer days with sailing and swimming in the 5-acre lake. Pavilions for picnics and dancing, horseback riding along the shore, and lemonade stands were enjoyed by hundreds. (Griffith Archives.)

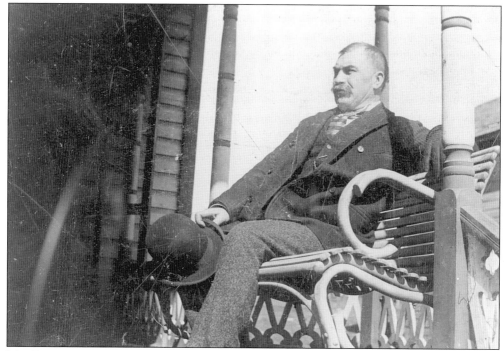

MR. BAKER AT HOME. Longtime friends of Frank Harrah, the Bakers lived north of Oklahoma City near the Deep Fork River. Here Mr. Baker relaxes on the porch of his rural home. (John Dunning "Okie Archives.")*

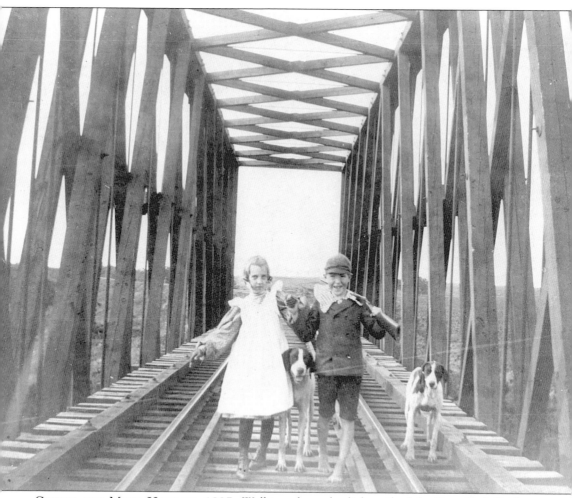

CALVIN AND MARY HARRAH, 1897. Walking along the light rail of the Deep Fork Bridge are Calvin and Mary Harrah. The two often visited the Baker family. (John Dunning "Okie Archives.")*

Baker Home Along the Deep Fork River. This photograph of the Baker property shows just how close the home was to the river. (John Dunning "Okie Archives.")*

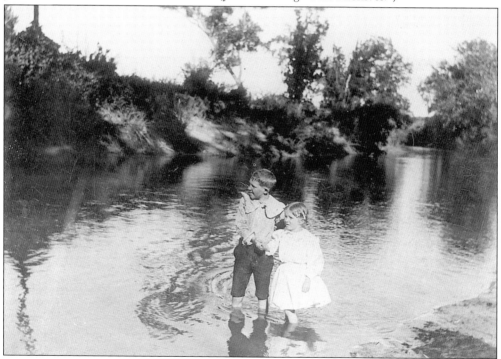

Searching for Bears. Calvin Harrah and Julia Baker are startled by noises coming from the undergrowth along the river. The caption under the photograph suggests that bears may be nearby. (John Dunning "Okie Archives.")*

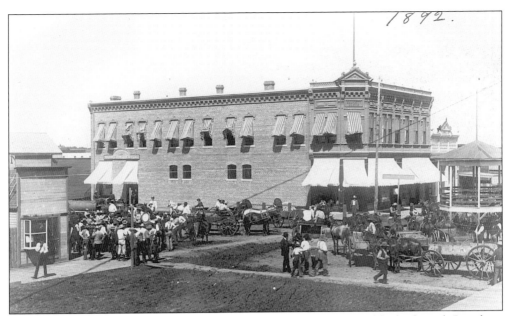

BASSETT BLOCK. The five-story brick building was located in the 100 block of North Broadway Avenue. Mrs. C.L. Wilson operated her millinery shop in the building. (Griffith Archives.)

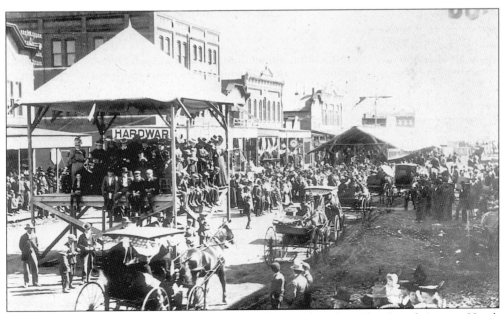

OKLAHOMA CITY STREET FAIR. This photograph was taken from the Grand Avenue Hotel, looking east along Grand Avenue during a street fair, which ran from October 10th through the 15th. Fresh produce could be purchased for a few cents. (Griffith Archives.)

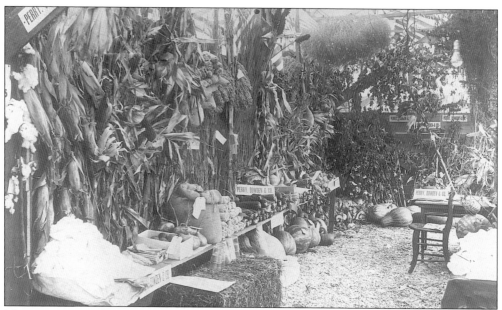

MARKET, 1898. The Perry, Dowden & Co. display an agricultural exhibit in Oklahoma City. (Archives & Manuscripts Division of OHS.)

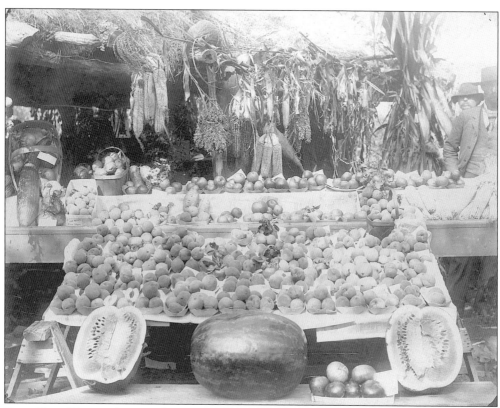

YUM, YUM. This produce stand was one of dozens on display at the street fair in 1898. (Griffith Archives.)*

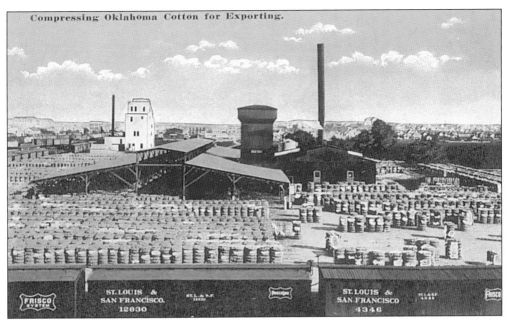

Compressing Oklahoma Cotton for Exporting.

COTTON IS KING. Covering 7 acres and 7,000 feet of track, the Cotton Compress shipped bales of cotton until 1969. The loading platform was lined with red wooden barrels, filled with water in case of fire. (Griffith Archives.)

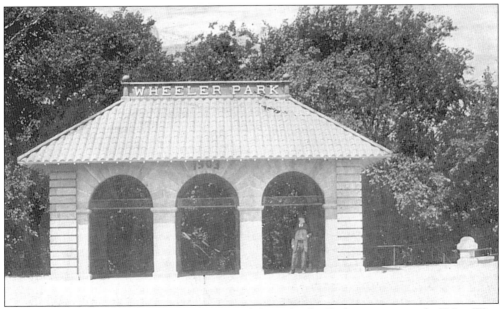

WHEELER PARK c. 1903. This postal view of the Wheeler Park entrance reads: "Mrs. Wm. Harn, 509 Broadway Avenue, Oklahoma City, Okla." It was addressed to a Miss M. Holmstedt, 322 Walnut Street, Helena, Arkansas, and continues on the back: "you will be surprised to hear but my address is at Oklahoma City so if you wish to play cards from here, come again. Your Friend, Mrs. W.F. Harn." (Harn Homestead & 1889er Museum.)

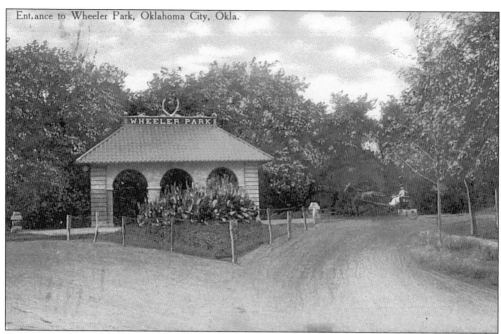

WHEELER PARK

STONE ENTRANCE, c. 1903. J.B. Wheeler donated 35 acres for a city park. Wheeler stipulated that at least $2,000 be appropriated each year for maintenance and improvements. Visitors walked through a massive stone entrance, into the city's first zoological park. (Griffith Archives.)

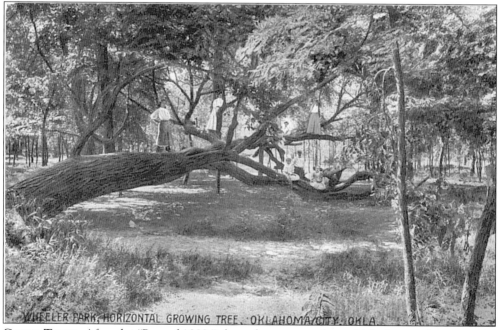

WHEELER PARK, HORIZONTAL GROWING TREE, OKLAHOMA CITY, OKLA

GIANT TREES. After the "Run of 1889," the only trees people could find were those growing along the North Canadian River. This scene shows people standing on a horizontal tree. The back of the photograph reads: "Master Amsley, I am still envious of you, but will sweeten up and send you this card. Polly." (Griffith Archives.)

SPENDING TIME AT THE ZOO c. 1900.
These two views show the wildlife attraction
at the park. The caption on the top postcard
reads: "After bread & honey." Children
loved to watch the animals like those in the
Sea Lion Pond, shown in the bottom view.
(Griffith Archives.)

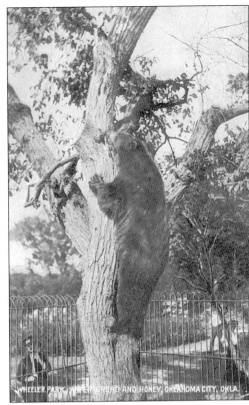

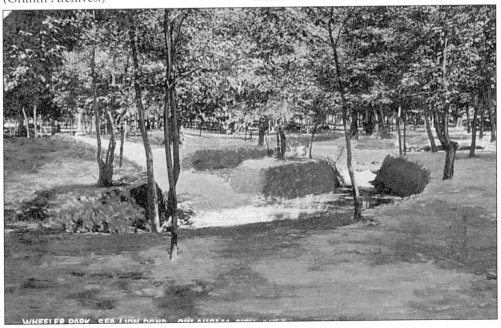

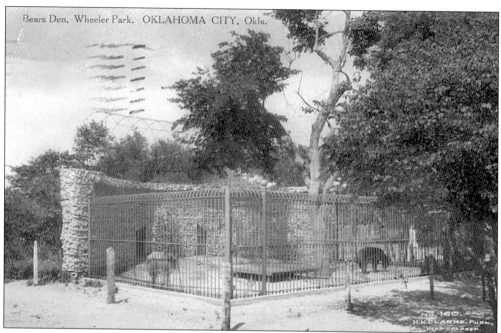

BEARS AT THE ZOO c. 1900. Bear activity has always been a favorite sight for visitors at the zoo. Here some guests watch as two bears play in their den. (Griffith Archives.)

WHEELER CONSERVATORY c. 1900. The bedding plants were grown in a controlled environment for transplanting in Wheeler and other city parks. Visitors seldom visited the greenhouses. (Griffith Archives.)

Among the Cannas in Wheeler Park, Oklahoma City, Okla.

AMONG THE CANNAS. Two men are seen standing among the giant cannas, which were grown outside the conservatory. The greenhouses supplied flowers to all the city parks, and perhaps a few front yards. (Griffith Archives.)

THE NORTH CANADIAN c. 1900. Couples could rent boats to row up and down the beautiful North Canadian River, which supplied water for the conservatory and animals. This view shows a peaceful river, but in 1932 the zoo was moved after the "Great Flood." (Griffith Archives.)

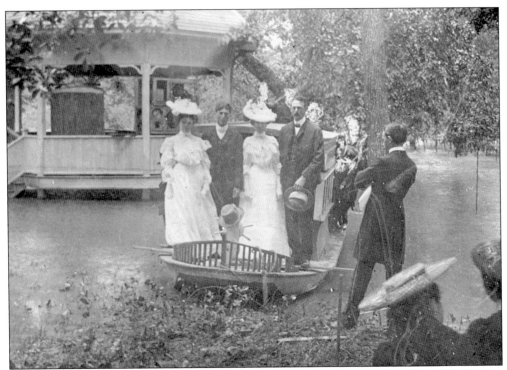

DOUBLE WEDDING C. 1900. These unidentified couples are "taking the plunge" by having their wedding vows given while standing in a boat. (John Dunning "Okie Archives.")

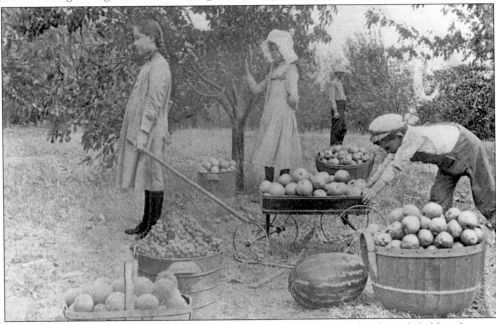

HARVEST TIME, 1900. Not the usual chore around the farm, these school-aged children harvest apples, grapes, and watermelons for sale at the market on Saturday. Phil Daugherty recalls how he would "go out to the Harn's and pick strawberries." Occasionally he would eat so many he would break out in a rash. (Archives & Manuscripts Division of OHS.)

MRS. WILLIAM J. PETTEE, 1900. Daisy Pettee made the Run of 1889 at the age of 18. She and her husband operated the W.J. Pettee & Co., 121–123 West Main Street (telephone number 2094). (Harn Homestead & 1889er Museum.)*

1898			
upr.	28	Of char. B.D.H.	1.20
May		copy complat (for.C.L.B) (Shutter)	3.10
"	25	For returning un- perfected appeal Etc in Hodge v. Foster Et al. to Prob. Judge.	1.40
"	"	John Rapp &af. to make proof on residence 35 years, in naturalization.	2.00
June	2	Howe contract Tonkawa in triplicate & Ponca in triplicate 9 attests 9 seals.	3.15
"	29	To Cash Cert Abstr. J.V. Kvogle	.50
June 20		Jno Rettabler 1st papp	2.50
July 1		Fred. Wm Kump letters	2.50
July	6	To cash first & final papers John Gelenter	4.40
July	8	Abstract Kvogle	7c

NOTES FROM 1898. This page is from a record of legal proceedings and notes Mr. Harn inscribed in a notebook he used while special agent for the Department of the Interior. Mr. Harn practiced law for many years. When C.G. Jones and Henry Overholser owned the St. Louis & Oklahoma City Railroad, Mr. Harn served as their legal council. (Harn Homestead & 1889er Museum.)*

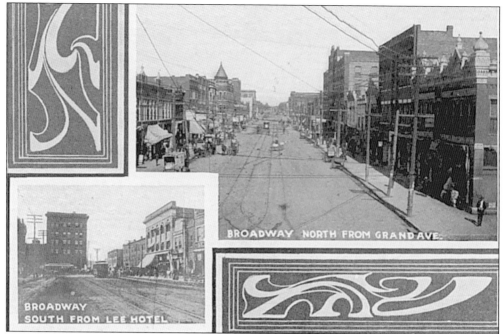

FIRST PICTURE POSTAL CARDS, 1901. The first photograph postal card in Oklahoma City was sold by F.J. McGlinchey on February 2, 1901, when he received 72,000 from New York City. These two views show Broadway Avenue north from Grand Avenue and then south from the Lee Hotel. (Griffith Archives.)

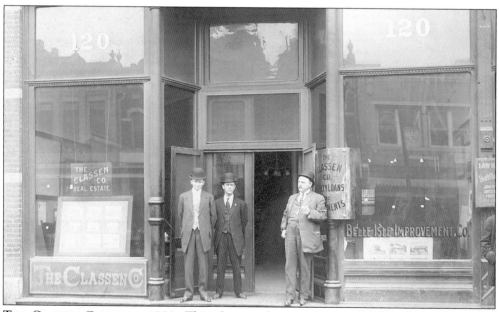

THE CLASSEN COMPANY, 1902. This photograph was taken at 120 West Grand Avenue. Standing on the right is Anton Classen, who made the Run into Edmond. He moved to Oklahoma City in 1897 and began to practice law and sell real estate. In 1902, he founded the Belle Isle Improvement Company. (Griffith Archives.)*

Three

THE NEW CENTURY

The new century brought new prosperity and growth to Oklahoma City. The United States census numbered the population at 14,369. This phenomenal economic growth continued with the construction of new commercial buildings, valued at more that $1.2 million. The business district was fronted by 7,900 feet of brick or stone buildings. On January 30, 1902, the city council granted a franchise to the Metropolitan Street Railway Company, and the first electric-powered cars began service on February 2, 1902, on 6.5 miles of track.

The city grew northward and the building frenzy continued. New homes were constructed in areas called Colcord Heights, Classen's Highland Park Addition, and Winnan's Addition. Social life in the city blossomed. It would be impossible to tell, even in briefest detail, the thousands of groups that did so much for the city. Mrs. Sewyln Douglas founded the "Do All You Can" (DAYC) club in 1901, which later became the Cosmopolitan Study Club. Mrs. James H. Wheeler organized a bowling and bridge club in 1902. Mrs. Henry Overholser held a lavish reception and party at her present-day residence. Four hundred of the city's finest residents gathered to toast the prosperity of their city. The Lotus Club organized in 1905 as did the 89er Association, which held its first meeting in Wheeler Park, where the first professional baseball team played ball. The Empire Theater opened in 1903, at 216 N Broadway Avenue. The theater was immediately north of the Rock Island depot, and noise forced plays to be delayed whenever trains passed through. The Empire closed in 1907, as did the empire of "Big Anne" Wynn. She had ruled the "underworld" of the city for 18 years as the "Madam," when a jury acquitted her of arson and murder. She packed her bags and moved to Los Angeles, California, where she died a few years later.

MRS. MARION TUTLE ROCK.
Mrs. Rock wrote a book called the *Illustrated History of Oklahoma: The Land of the Fair God* in 1890. She also held the position of librarian of the new Carnegie Library from 1901 to 1907 with a salary of $50 per month. In 1902, it was raised to $70. (Philanoma Club Collection of the Harn Homestead & 1889er Museum.)*

CUNNINGHAM FAMILY c. 1902. J.W. and Mary S. Cunningham sit with their children, Oklahoma Belle, Mary Myrtle, Foster, and Occa Jefferson. Mrs. Cunningham was with child when she and J.W. made the Run into the Oklahoma Country. She gave birth to Oklahoma Belle on May 2, 1889, making her the first child born in Oklahoma Station (City). (Cheever Family Collection of the Harn Homestead & 1889er Museum.)*

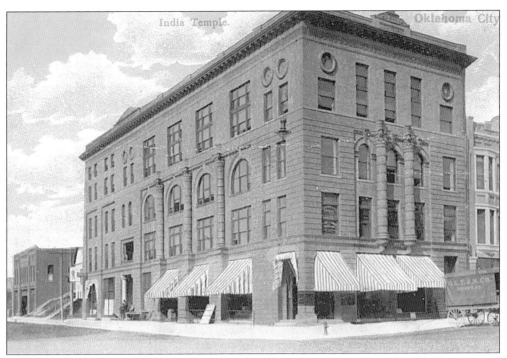

INDIA TEMPLE, 1902. The second home for the Mason's was located at 101–111 West Second Street until 1910. The Temple was renamed the Wright Building, and for a time, the Oklahoma State Legislature met here until the state capitol was completed in 1917. (Griffith Archives.)

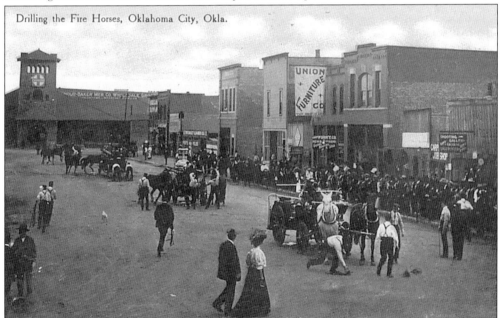

CENTRAL FIRE DRILLS C. 1902. The two horses seen here are Jumbo and Babe, pulling a hook and ladder wagon during fire drills on West Reno Avenue. The fire department maintained a stable of 40 fire-trained horses pulling most of the rolling stock as late as 1917. (Griffith Archives.)

NOVELTY CARDS c. 1905. Simple yet personable, this postal card conveys "Greetings from Oklahoma City" in glitter. Many smaller towns used these "glitter" cards to help promote their existence. The card below featured a small envelope in which the sender could write a short letter. This one is written in German. (Griffith Archives.)*

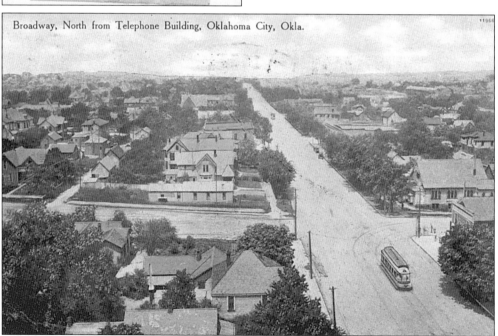

Broadway, North from Telephone Building, Oklahoma City, Okla.

BROADWAY AVENUE NORTH c. 1902. Taking the streetcar downtown or to the gardens was faster than by horse and buggy. This postal view was taken from Fourth Street looking north. (Griffith Archives.)

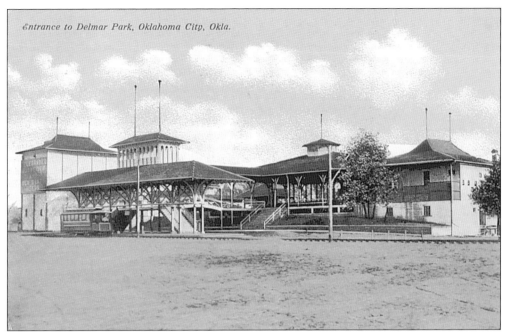

GRAND ENTRANCE, 1902. Ten streetcars provided public transportation to the multi-story loading and unloading platform at the Gardens. The sign on the left reads: *Anheuser-Busch Celebrated Budweiser & New Malted Beers.* Oklahoma came into the Union as a dry state. (Griffith Archives.)

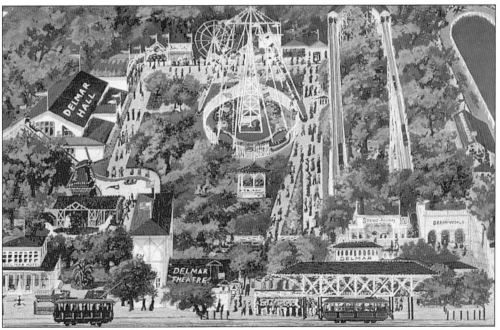

DELMAR GARDENS. This view shows an artist's conception of a bird's-eye view of the park. John and Peter Sinopoulo and Joseph Marre purchased 140 acres from Charles Colcord for Oklahoma City's first amusement park. (Griffith Archives.)

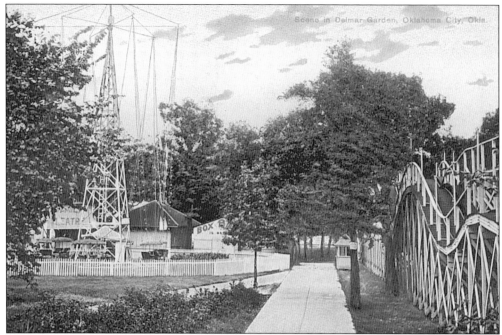

RIDE THE COASTER. The giant swing as well as the roller coaster has long been an attraction for amusement park visitors. Barely visible in the background is a sign that reads: *Family Theater.* (Griffith Archives.)

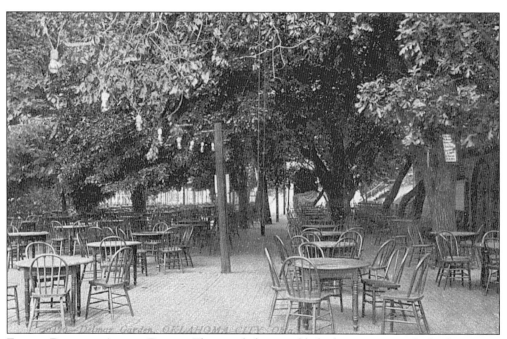

ENJOY DELMAR AFTER DARK. Electric lights enabled the eating and drinking area to accommodate visitors in the late evening and the trees provided shade during the day. (Griffith Archives.)

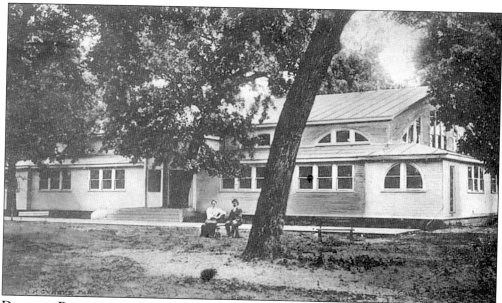

DANCING PAVILION c. 1903. Ten streetcars brought visitors from downtown to the Gardens. The pavilion would have been a place for couples to dance the Two-Step or the Rag. (Griffith Archives.)

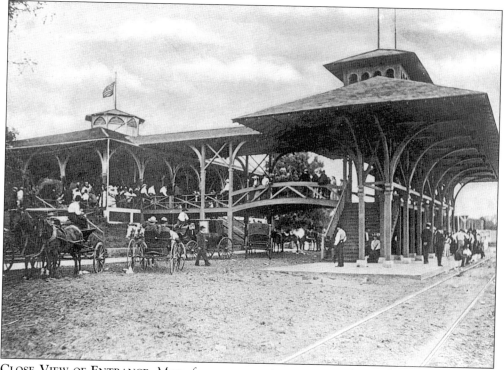

CLOSE VIEW OF ENTRANCE. Many famous entertainers came to the garden. Lon Chaney Sr. played in *The Mikado*, Madame Nordica sang there, John L. Sullivan performed in an exhibition boxing match, Buster Keaton performed there with his parents at age three, and Chief Geronimo sold autographs for a dime. (John Dunning "Okie Archives.")*

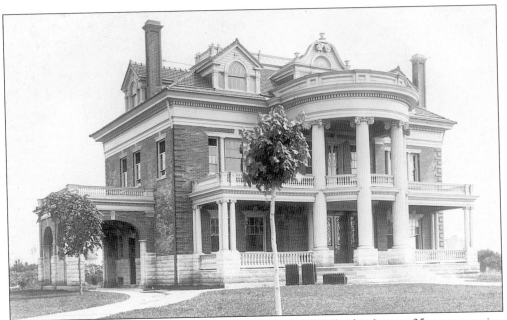

COLCORD HOME, 1903. Built and designed by William A. Wells, this 3-story, 25-room mansion was the home of Charles Francis Colcord—former cowboy, builder, first Oklahoma County sheriff, and Oklahoma City police chief. (Charles Turner Hocker Collection of the Archives & Manuscripts Division of OHS.)

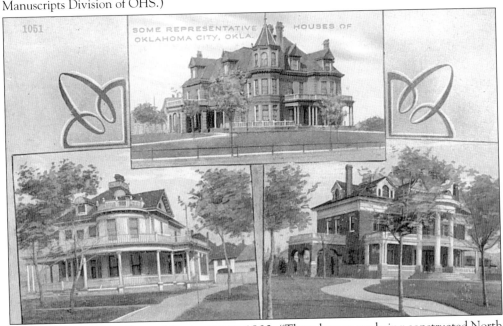

THE *Oklahoma Time-Journal* REPORTED IN 1903. "Three homes are being constructed North of this city, at a cost of $35,000 to $55,000." Pictured from left to right are the homes of Mayor Lee Van Winkle, 231 East Tenth Street, in a Queen Anne style with wrap around porch; Henry Overholser, 405 North Fifteenth Street, built by W.S. Matthews in the Chateau style with traces of Queen Anne and Eastlake; and Charles Francis Colcord, 421 West Thirteenth Street, in the Colonial Revival style. The Colcord home was razed January 1965. (Griffith Archives.)

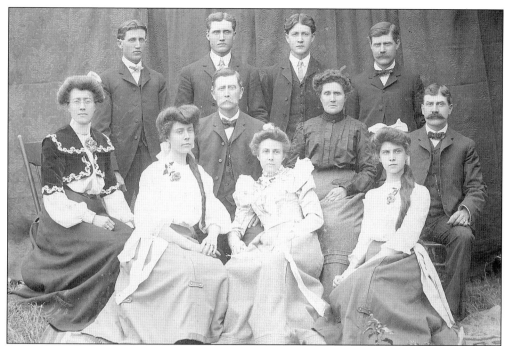

STONE FAMILY, 1903. Mr. L.B. Stone and his wife, Josephine, are shown with daughters (in white) Genevive, Mildred, and Jose (others are not identified). Not long after this photograph was taken, Mr. Stone passed away. Josephine made her residence at 416 West Thirteenth Street. (Griffith Collection.)*

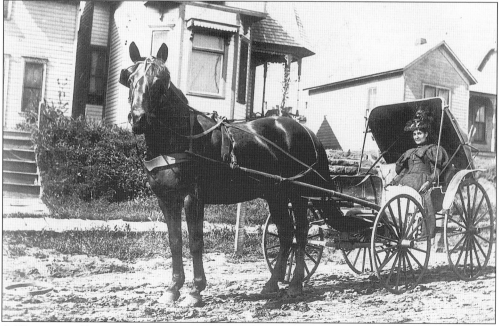

A HANDSOME LADY, 1903. Mrs. W.O. (Jamie) Church is seen here in front of her home at 210 East Second Street. Mr. Church was president of S.W. Grain and Coal Co. (W.O. Church Collection of the Archives & Manuscripts Division of OHS.)*

CASTLE ON THE HILL, 1903. Henry and Anna Overholser moved into their new home in the spring of 1904. This view was taken from the A.T. & S.F. tracks looking west, on the Harn property. (Griffith Archives.)

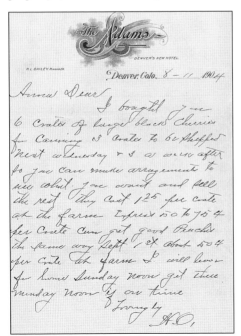

CAPITALIST. In 1904, the 58-year-old Henry Overholser wrote to his wife, Anna, from Denver, Colorado, where he owned silver mines at Mosquito Pass, near Leadville. (Overholser Mansion Collection of OHS.)*

FIRST LADY OF OKLAHOMA CITY. The 18-year-old Miss Anna Ione Murphy would find herself engaged and then married to the 43-year-old capitalist after only a two-month courtship. Their August wedding was a private affair, in the apartments of her parents, which were just four doors west of her new apartments. This photograph shows Mrs. Overholser, taken around 1904, in a Charles Frederick Worth gown. (Overholser Mansion Collection of OHS.)

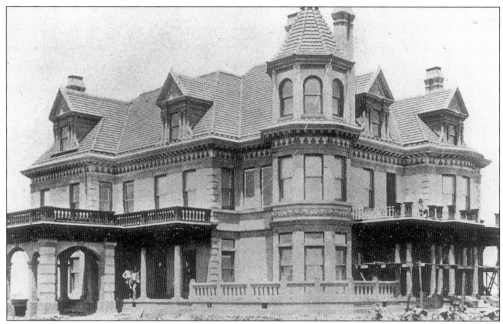

APRIL 1903. This view shows the Overholser home near completion. Mrs. Overholser gave her first party in 1904, to 400 lucky guests. The *Times-Journal* society column reported that as guests entered the home, they were greeted by a string quartet playing on the second floor turret landing, hidden by a blanket of palm and fern. (Overholser Mansion Collection of OHS.)

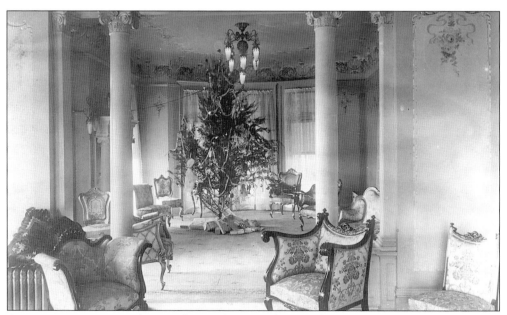

CHRISTMAS, 1906. People came from miles around to see the Overholser's electric Christmas Tree. This photograph was taken from the music room looking into the drawing room. The walls of the home are covered in canvas and hand decorated to compliment the carpets. Note the electric cord running from a wall sconce to the top of the tree. (Overholser Mansion Collection of OHS.)

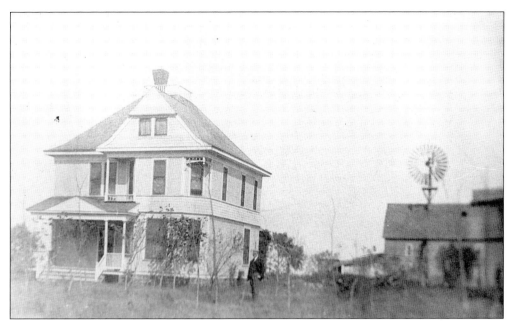

HARN HOME c. 1905. In 1891, William Fremont and Alice Harn purchased the title to 160 acres, a two-room cottage, and a water well from James H. Carter for $425. In April 1904, the Harns moved into their new home, which they ordered from an 1890 National Builders catalogue. Note the windmill protruding from the barn roof. (Harn Homestead & 1889er Museum.)*

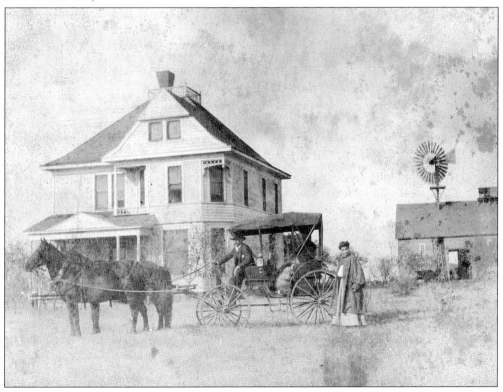

STATEMENT.

Oklahoma City, Okla. Dec - 12 1903

M.... Lowenstine

IN ACCOUNT WITH

McCredie Hardware Co.

Corner Robinson and Grand Avenue.

Bell Phone 157.

Nov	12	Blacking & setting up stove.	75
	26	1 - Keg - 8 com.	325
		30# - 16 } 20# - 20 } 80# - 30# - 3 }	260
	30	2 Pr. B D Rollers.	150
		34 ft. Barn Door Track.	187
		4 Pr 6 in St Hinger.	60
X		Flue Thimble	15
Dec	1	24 - 6# sash wts 144 - 1.75	288
		9½# sash cord.	135
		6 sash locks.	75
	2	20# 8ᴺ nails } 5# 6ᴰ " } ------	90
	4	1 - Doz - Bar Meat Hooks.	100
		20 ft B Door Track.	100
		Pr B Door Hanger.	75
		2 Pr 6 in St Hinges.	30
X		6 - 6 in Hooks & Staple.	60
		4 - 6 " Bbl Bolt	60
		1 Doz B.B. Sash Pulleys.	40
		10# 8 com.	35
		5 Safety B. Hooks.	50
		1 Pr Hanger.	75
		2 ft. Track.	10

McCredie Hardware, 1903. What would these supplies cost today? (Harn Homestead & 1889er Museum.)*

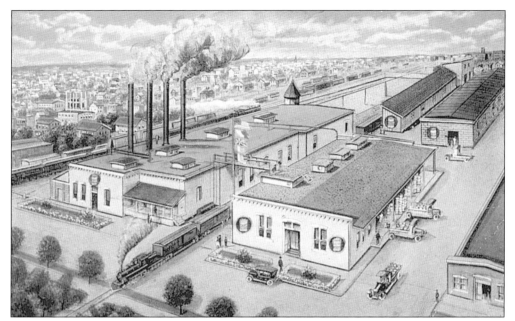

I Scream, You Scream, We All Scream for . . . Crystal Ice Cream was founded in 1902 and opened for business in May 1903. Located in the 800 block of South Robinson Avenue, the Crystal plant housed steam engines that ran compressors for making ice. (Griffith Archives.)

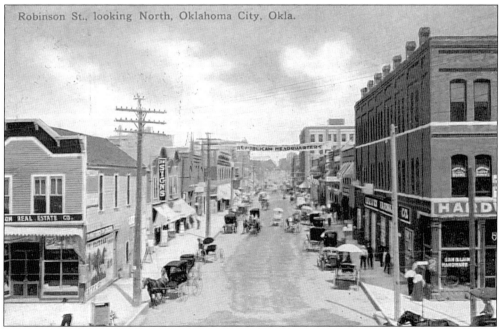

Robinson Avenue Looking North c. 1901. The McCredie Hardware Co. can be seen on the right of this postal view. Henry Overholser's apartments are on the second floor of the building on the left. (Griffith Archives.)

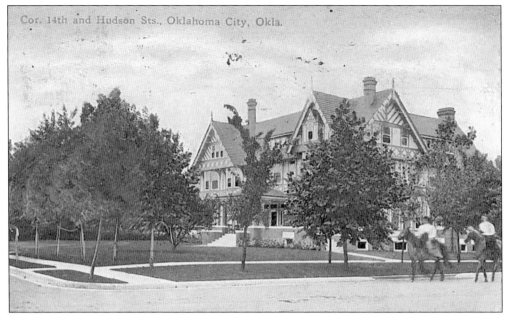

COOKE MANSION, 1904. In 1893, Edward H. and Edna Cooke moved to Oklahoma City, where he took control of the failed State National Bank. In 1904, the Cookes moved into their 15-room mansion that featured Elizabethan architecture, a ballroom on the third floor, and a 6-by 9-foot stained-glass window depicting a multi-colored peacock. (Griffith Archives.)

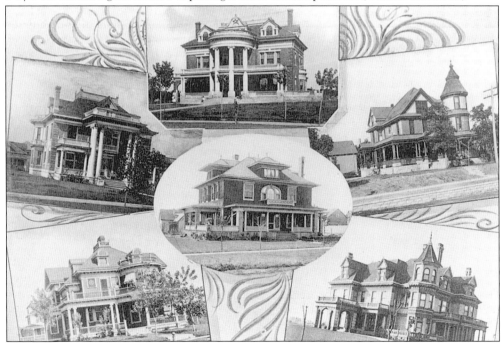

COLLECTION OF HOMES, 1903. These homes are a good representative of the 1903 housing boom, which occurred north of downtown. Pictured from left to right are the homes of James Maney, John "Chubby" Martin, Charles Colcord, Captain Daniel Stiles, Henry Overholser, and the home of an unknown owner in the center. (John Dunning "Okie Archives.")

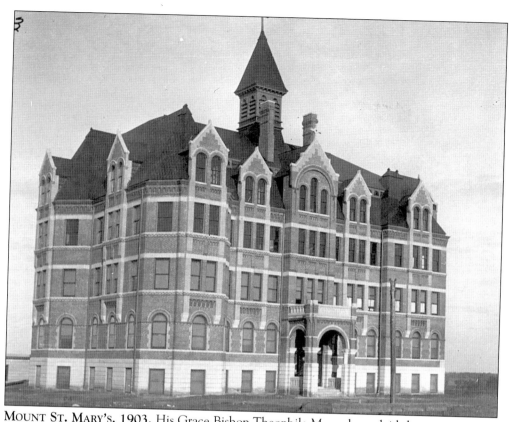

MOUNT ST. MARY'S, 1903. His Grace Bishop Theophile Meerschaert laid the cornerstone of Oklahoma City's first Catholic academy on December 18, 1903. It was completed and opened its doors for the first term in 1906, with an enrollment of 35 students. Mount St. Mary's is still in use today. (Griffith Archives.)

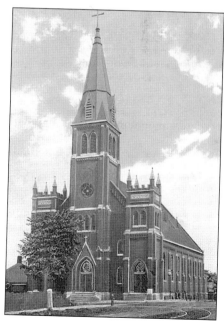

THE OLD CATHEDRAL, 1903. The second building to carry the name St. Joseph Catholic Church is located on the corner of Harvey and Fourth Streets. Dennis T. Flynn donated the stained-glass windows. The old cathedral and windows were heavily damaged in the 1995 bombing of the A.P. Murrah Federal Building. (Griffith Archives.)

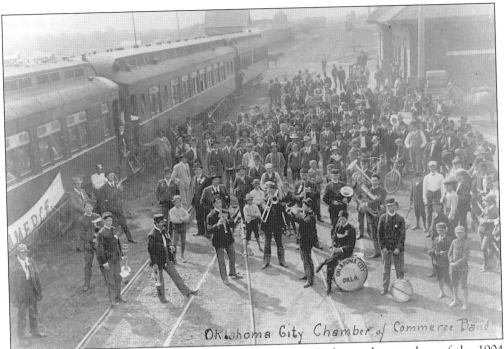

AND THE BAND PLAYS ON, 1904. Taken at the Santa Fe depot, the members of the 1904 Oklahoma City Chamber of Commerce Band pose for the camera before a territorial promotion tour. (Archives & Manuscripts Division of OHS.)

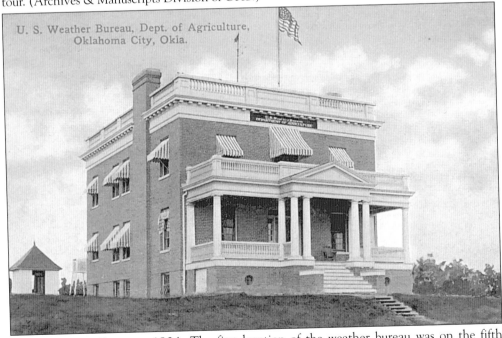

U.S. WEATHER BUREAU, 1904. The first location of the weather bureau was on the fifth floor of the Culbertson Building. In 1904, a 100-by-150-foot site on the southwest corner of Classen Boulevard and Nineteenth Street, was purchased from Epworth University for $10. (Griffith Archives.)

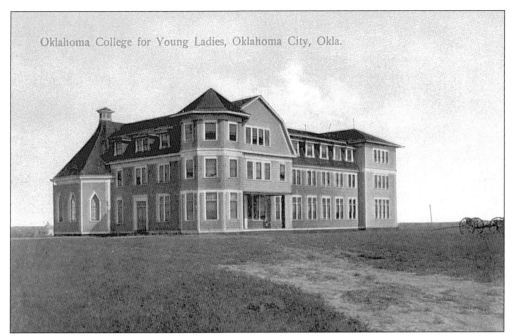

Oklahoma College for Young Ladies, Oklahoma City, Okla.

OK STATE MILITARY INSTITUTE, 1903. This structure was incorporated in June as a preparatory school for young men from the Indian and Oklahoma Territories. The academy closed shortly thereafter and reopened as the Oklahoma College for Young Ladies. The structure burned in 1909. (Griffith Archives.)

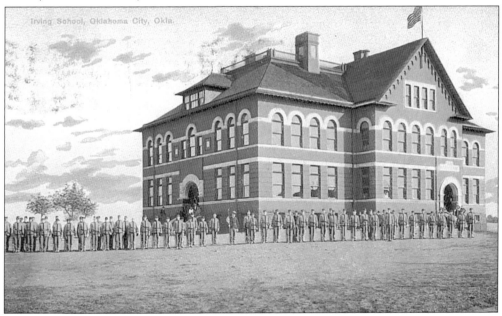

Irving School, Oklahoma City, Okla.

IRVING SCHOOL—TEMPORARY STATE CAPITOL, c. 1901. Located on the southeast corner of East Fourth and Walnut Streets, Irving was one of the first schools constructed prior to statehood. The bottom view shows uniformed cadets on the playground. They moved to their new academy in 1903. When the capital was moved from Guthrie in 1910, Irving was used as the temporary state house. The historic structure burned in 1937. (Griffith Archives.)

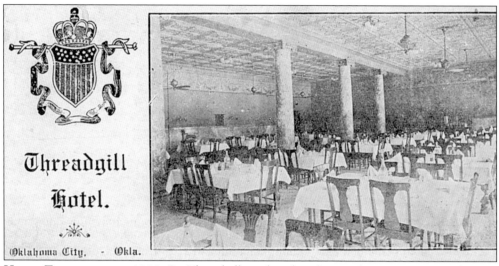

HOTEL THREADGILL, c. 1903. Dr. Threadgill was listed in the city directory as a capitalist. He built this hotel on the northeast corner of Second Street and Broadway Avenue. This postcard was detached from a hotel menu. (Griffith Archives.)

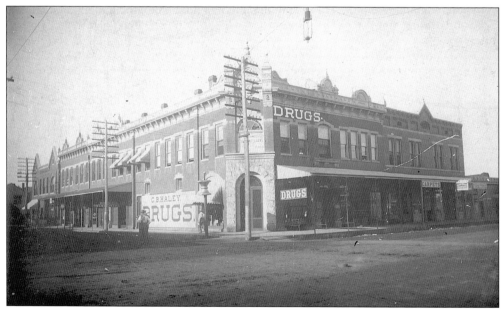

C.B. HALEY, DRUGGIST, c. 1905. The city directory listed Haley Drugs at 230 W. Main Street, phone 31. On the right, the one-story building housed Reed & Mueller Undertaking & Furniture, 307 N. Broadway Avenue, phone 570. (Harn Homestead & 1889er Museum.)*

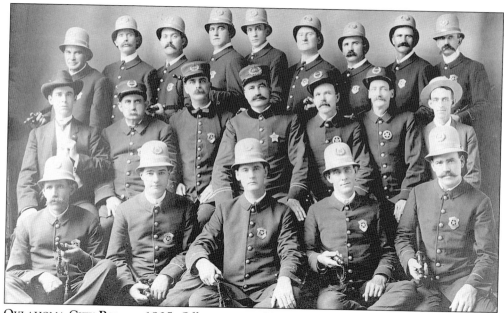

OKLAHOMA CITY POLICE, 1905. Officers pictured here, from left to right, are as follows: (front row) Frank Benesh, Fred W. Right, George T. Trusty, Ike Shelvy, and Charles Gordon; (middle row) Detective Fred Hagen, Jailer J.H. Bols, Captain of Detectives R.W. Cochran, Chief Wagner, Sergeant Belle, James Gaston, and George Sampson; (back row) George Wagner, John T. Macarty, Joseph E. Palmer, Will Light, Lester Brown, unknown, William Inman, Charles W. Armstrong, and John H. Dean. (John Dunning "Okie Archives.")*

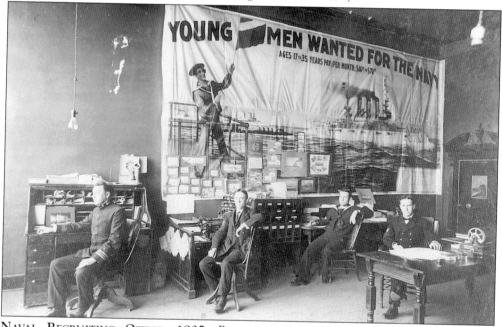

NAVAL RECRUITING OFFICE, 1905. Recruiters pictured from left to right are Hun, unidentified, Walter, Brown, and Bush, who are recruiting for Admiral "Fighting" Bob Evans and the Great White Fleet. The office was located at 220 West Grand Avenue. (John Dunning "Okie Archives.")*

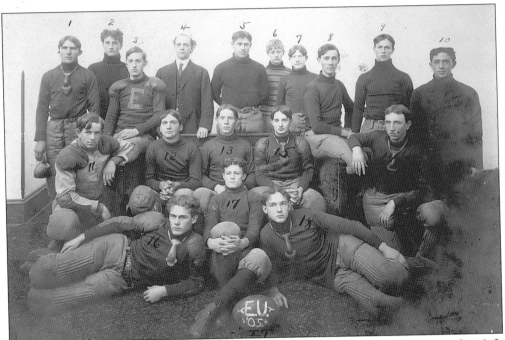

EPWORTH UNIVERSITY FOOTBALL TEAM, 1905. From left to right are as follows: 1. Lee ?, 2. Warren Fretz, 3. Harry Capley, 4. Dr. G.H. Bradford, chancellor, 5. William Orr, 6. Jack Piner, 7. Enoch Lusk, 8. John Staveley, 9. Fred Bukler, 10. M. Loewenstein, mgr., 11. Leonard West, 12. William Goff, 13. Marvin "Red" Wickline, 14. Walter Thomas, 15. Harry Campbell, 16. Robb Carle, 17. William R. Winn, captain, and 18. Jack Knowlton. "Her first successful team." (Griffith Archives.)*

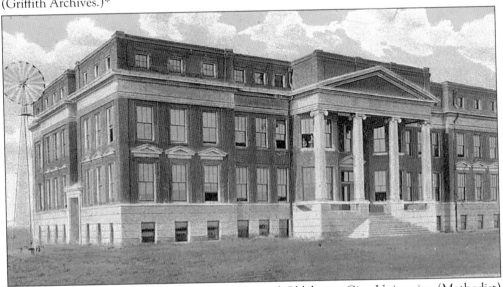

EPWORTH UNIVERSITY, 1902. The forerunner of Oklahoma City University (Methodist) was Epworth University, shown here at North Eighteenth and Douglas Streets. In September 1903, the brick and sandstone building was opened with an enrollment of 75 students and a 27 member faculty. The structure cost $40,000 and, today, is home to Epworth United Methodist Church. (Griffith Archives.)

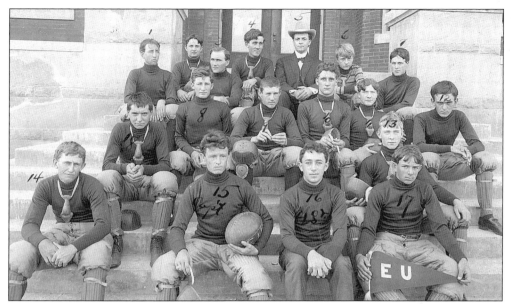

FOOTBALL TRYOUTS BEFORE TEAM PICKED, 1906. This photograph identifies the players by numbers: 1. Walter Thomas, 2. Harry Campbell, 3. "Rev." Andrews, 4. John Staveley, 5. Dr. G.H. Bradford, chancellor, 6. Jack Piner, 7. Fred G. Bukler, 8. William Doty, assistant captain 9. Bert Strong, 10. Warren Fretz, 11. Enoch Lusk, 12 ? Milliard, 13. Harry Popham (?), 14. Albert Rankin, 15. William R. Winn, captain, 16. M. Loewenstein, manager, 17. Leonard West, and 18. William Goff. (Griffith Archives.)*

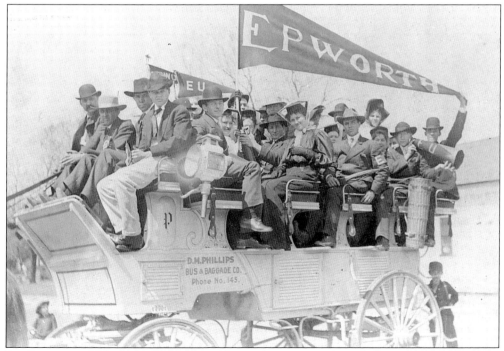

PEP RALLY FOR EU, 1906. This group of fans is shown going through the city in support of the home team. (John Dunning "Okie Archives.")*

FRESH AIR, c. 1906. The Honorable Dennis T. Flynn moved his family to Oklahoma City from Washington D.C. in 1902 and lived in the Grand Avenue Hotel until this home was built. Their hotel rooms had no windows and only a single light that was suspended from a wire, which constantly flickered. (Streeter B. Flynn Jr. Collection, Oklahoma City.)*

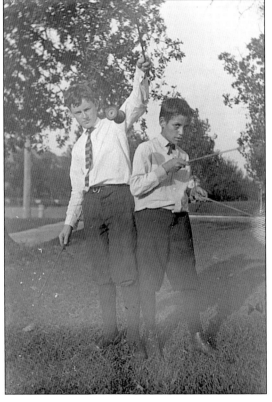

FLYNN BOYS, c. 1906. This photograph of Streeter B. Flynn Sr. (left) and Olney F. "Budge" Flynn (right), with games, was taken in their front yard at 401 Northwest Thirteenth Street. Streeter was born November 2, 1892, in Guthrie, and Olney was born in Washington D.C. (Streeter B. Flynn Jr. Collection.)*

INTERIOR VIEW, c. 1906. Photography was a favorite hobby of Streeter B. Flynn. This view is of one of the bedrooms in the Thirteenth Street home. (Streeter B. Flynn Jr. Collection.)*

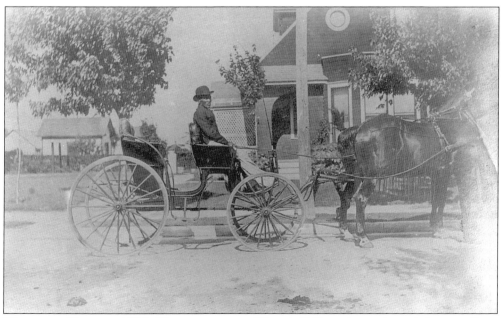

WASH AND TEAM, c. 1906. The manservant of Dennis T. Flynn is seen here sitting proudly at the reins on Thirteenth Street. (Streeter B. Flynn Jr. Collection.)*

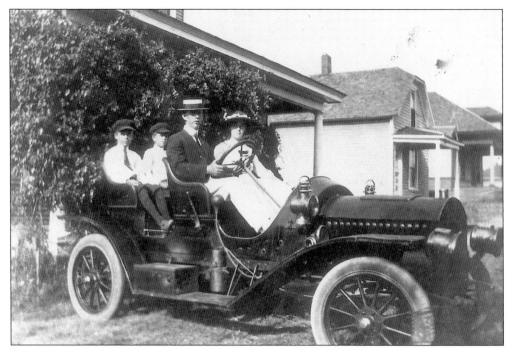

THE NORTHRUPS, 1906. Pictured here are Mr. and Mrs. John A. Northrup with sons, Loy and Clyde, in their 1907 Model K-7 Los Angeles Tourist, which cost around $1,500. This two-cylinder auto would reach a top speed of 20 m.p.h. (Archives & Manuscripts Division of OHS.)*

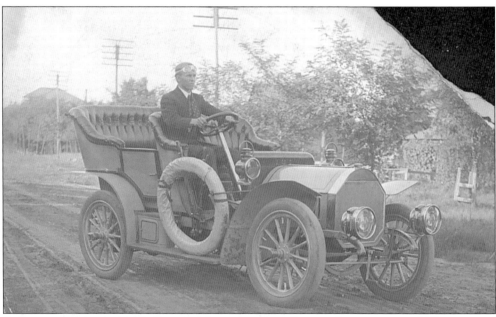

A LOCOMOBILE, c. 1906. Pictured here is young Barney Stewart, son of Thomas and Elizabeth Stewart, sitting in his Locomobile at 721 North Fifteenth Street. Built by A.L. Riker in Bridgeport, Connecticut, the first locomobile rolled off the assembly line in 1902. (Griffith Archives.)*

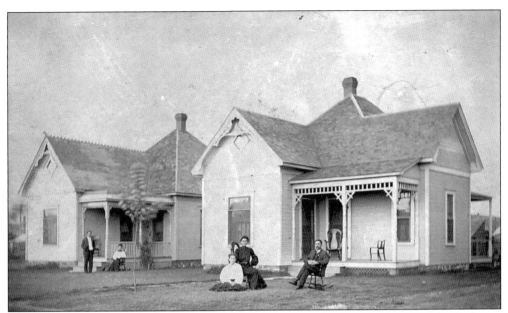

COOMBS FAMILIES, c. 1906. Pictured sitting in the front yard at 613 West California Street (left) are Albert E. and Annie. Located next door, at 615 West California Street, are Frank C. and Elizabeth with their daughter, Bertha. The back of the photograph says that 617 West California Street was a rented home. The Coombs came to Oklahoma just after 1900. (Griffith Archives.)*

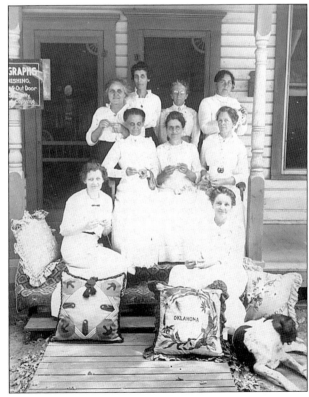

SEWING CIRCLE, c. 1906. These ladies are identified as Madams, Coombs, Clark, Laux, Chandler, Ashby, Townsend (middle, first row), Weathersbee, DeBolt, and Harkins. This photograph, by Oliver, was taken at the Coombs residence at 615 West California Street. (Griffith Archives.)*

LEATHER POSTAL CARDS C. 1906. While they were nearly impossible to write on, leather postcards were a great novelty. (Griffith Archives.)*

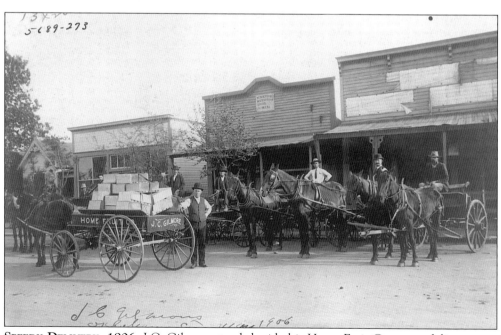

SPEEDY DELIVERY, 1906. J.C. Gilmore stands beside his Home Fruit Company delivery cart, located on West California Street. (Archives & Manuscripts Division of OHS.)

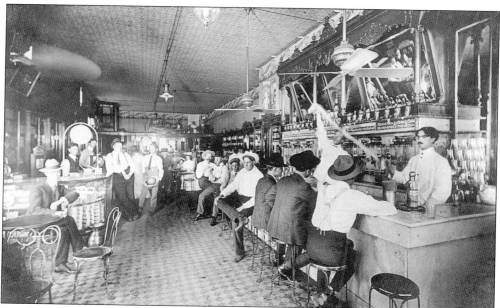

SODA JERKS PUTTING ON A SHOW, 1906. A listing for Westfall Drug Store appears in the 1903 city directory, with its location given as 200 West Main Street. It boasted of being the largest drugstore in Oklahoma. They had seven employees, three of whom were registered pharmacists. (John Dunning "Okie Archives.")*

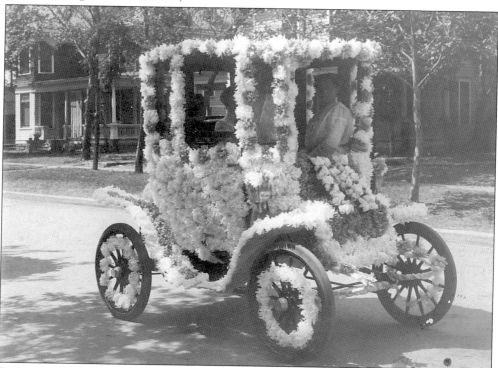

READY FOR A PARADE, c. 1906. While it is difficult to identify this car or its passengers, it is not difficult to tell that these ladies were proud of their handiwork. This electric car and the occupants posed before a downtown parade. (Griffith Archives.)*

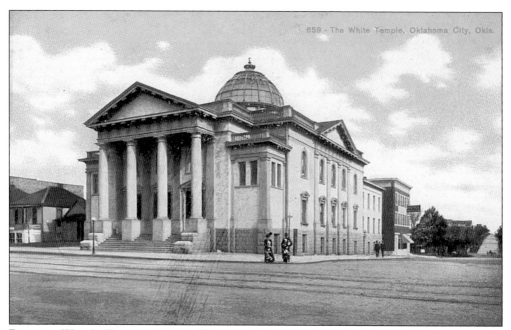

BAPTIST WHITE TEMPLE, 1906. Plans were being made to build a new church when a fire broke out during a prayer meeting on February 14, 1905, which destroyed the wooden structure. On September 23, 1906, the worshippers occupied their new building seen here. (Griffith Archives.)

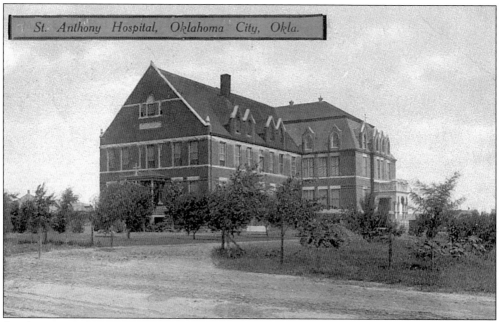

St. Anthony Hospital, Oklahoma City, Okla.

ST. ANTHONY HOSPITAL, c. 1906. In 1889, two Sisters of St. Francis from Marysville, Missouri, came to Oklahoma Station to solicit funds for a hospital in Missouri. When they approached Father D.I. Lanslots, priest of St. Joseph's, he told them of the great need for such a hospital here. Temporary quarters were begun the same year, and $800 was raised to purchase an entire block between Ninth, Tenth, Dewey, and Lee Streets. (Griffith Archives.)

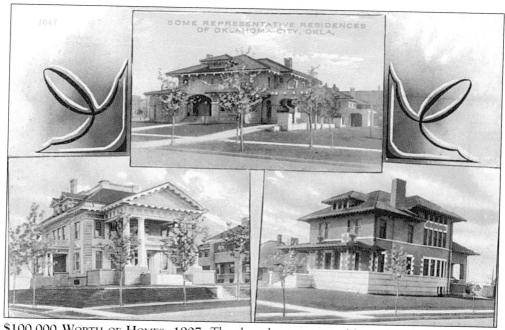

$100,000 Worth of Homes, 1907. The three homes pictured here, from left to right, are the homes of Hugh Johnson, at 438 West Fifteenth Street, built by Hawk & Collington in the Neo-Classical design; Richard Vose, at 436 West Fourteenth Street, built by J.W. Hawk in the Spanish style; and John M. Noble, at 501 West Fifteenth Street, built on strong horizontal lines reminiscent of the Frank Lloyd Wright Prairie style. (Griffith Archives.)

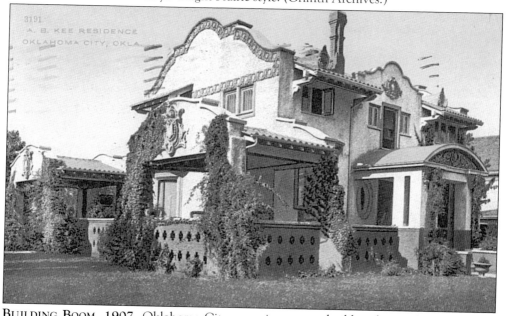

Building Boom, 1907. Oklahoma City was witness to a building boom that rivaled the one of 1903. Pictured here is the Oliver B. Kee home located at 500 North Fifteenth Street. Mr. Kee, president of Security Loan & Investment Co., hired the firm of Van Meter & Schmitt to construct this home in the South African Dutch Colonial style for his wife Rose. (Griffith Archives.)

No. 76

Emerson School Library

This entitles the holder to one share of stock in the Emerson School Library.

In Witness Whereof, the said Association has caused the certificate to be signed by its duly authorized officers and to be sealed with the Seal of the Association.

Dated this 12 day of Feb. A. D. 1904.

Eugenia Hutton Pres.

SCHOOL STOCK, 1904. Certificate Number 76 entitles the holder to one share of stock in the Emerson School Library. (Harn Homestead & 1889er Museum.)*

EXCHANGING SCHOOL PICTURES, 1903. This school photograph is a left over from primary school days. On the back it reads, "From Erma Snyder, Apr. 1903, Bryant School." (Heaney Collection of the Harn Homestead & 1889er Museum.)*

NOT MUCH IS KNOWN. The only identifying mark on this photograph is a name, Adolyn Richardson Young. (Heaney Collection of the Harn Homestead & 1889er Museum.)*

MRS. J.J. BURKE, c. 1906. This H.E. Smythe photograph shows Mrs. Burke dressed in summer attire. Mr. Burke was editor and publisher of the *Oklahoma Daily Journal*. The Burkes resided on Fourth Street, between Santa Fe and Broadway Avenues. (Griffith Archives.)*

112

WHAT A PRETTY GIRL, c. 1906. This Wenkle photograph shows Miss Ruth Katherine Benny at four years of age, standing very still and well-behaved for the camera. This photograph was given to Master Many Payne. (Harn Homestead & 1889er Museum.)*

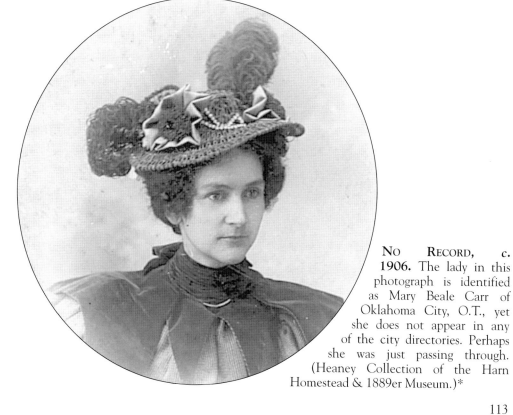

NO RECORD, c. 1906. The lady in this photograph is identified as Mary Beale Carr of Oklahoma City, O.T., yet she does not appear in any of the city directories. Perhaps she was just passing through. (Heaney Collection of the Harn Homestead & 1889er Museum.)*

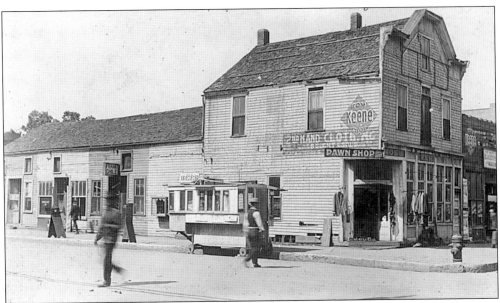

ALONG CALIFORNIA, c. 1907. This postcard view shows a secondhand clothing shop located at 200 West California Street and Robinson Avenue. The J.E. Carter Horseshoeing & Blacksmith shop was located at 202 West California Street (on the right). A sign reads, "Keg Beer" to the left of the shop, and haircuts were advertised for 10¢. (Griffith Archives.)*

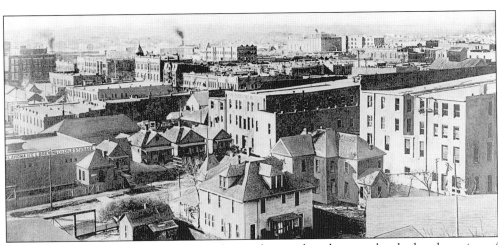

BIRD'S EYE VIEW c. 1907. Looking to the northwest, this photographer had a clear view of downtown. The building on the far right is the backside of the Hotel Threadgill. The building with the pointed top is the Western National Bank. On the lower right is the Oklahoma Ice & Brewing Companies Cold Storage. (Griffith Archives.)

Four

STATEHOOD

Oklahoma was admitted into the Union on November 16, 1907. A star would be added to the American flag on the following Fourth of July, and for the citizens of Oklahoma City, Oklahoma Territory, this would be a turning point. The population of the city numbered at 32,452, and the city had become the undisputed economic and social center of the future state. Of the 6,000 miles of railroad, all but 700 were operated by the "big four"—Santa Fe, Frisco, Rock Island, and the KATY. There were 145 jobbing houses that employed 1,300 people. Wholesalers sold more that $28 million in products to merchants all across the territory, and a large part of those sales were made in Oklahoma City, which was served by 350 retail establishments with a total volume of $19 million.

The State Fair of Oklahoma, an institution that would play a large role in the future of Oklahoma, opened in 1907. What began as many street fairs in 1892, the modern state fair began in the offices of the chamber of commerce on January 18, 1907. The meeting started with a general discussion of location, organization, and management, but quickly turned to financial needs. On the motion by Weston Atwood, the group of men present—C.G. Jones, Alexander W. McKeand, and Anton Classen—voted to charter the State Fair Association of Oklahoma with a capital stock of $100,000 to be divided into 10,000 shares, valued at $10 each. On February 25th, the directors adopted an amended version of the constitution and bylaws of the Dallas State Fair.

After the first state fair was over, it was on the brink of bankruptcy. On November 12, 1907, Henry Overholser arranged a $23,000 loan to the fair association and on the 14th he negotiated another loan for $25,000, payable at 8 percent interest over 5 years. In April of 1908, he loaned the fair association another $23,000, bringing his total cash outlay to more than $85,000.

By the time of the next fair in 1908, Henry's investment had handsome dividends. Total attendance was estimated at 100,000, but more importantly the revenues were $60,000 while expenditures (not counting capital improvements) were $46,000. In December, C.G. Jones resigned as president, and the board elected Henry Overholser to fill the position.

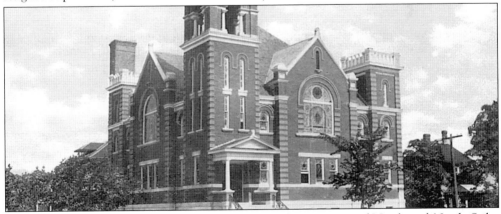

MAYWOOD PRESBYTERIAN, 1907. Built on the southeast corner of Ninth and North Stiles Streets in the Richardsonian-Romanesque style, the Maywood congregation used this structure until around 1980. The building has since been renovated and is now used by the Oklahoma Department of Commerce. (Griffith Archives.)

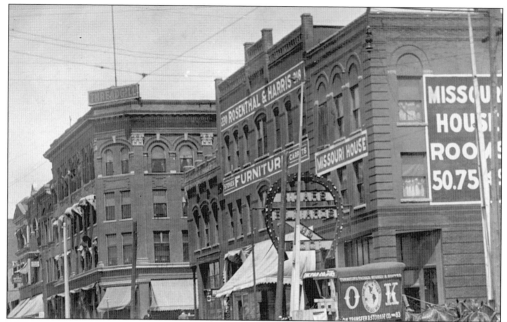

NEED A ROOM? This two-block section of Broadway Avenue, between First and Third Streets, housed not only the Hotel Threadgill but also the Missouri House, W.F. Edgar Rooms, Mrs Estella Henderson Room & Board, Mrs. Fredericka Rahn Rooms, Winger Flats, J.A. Mann Room & Board, A.L. McCauley Rooms, and The Richelieu. Rosenthal & Harris Furniture & Carpets Store was also located in this same area. (Griffith Archives.)

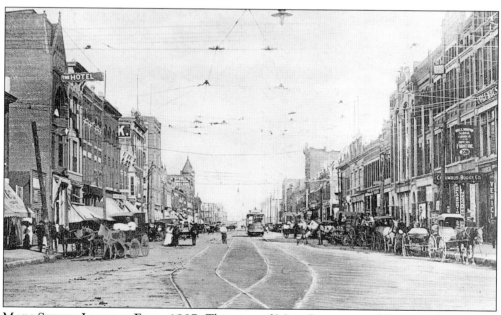

MAIN STREET LOOKING EAST, 1907. This view of Main Street, one of the central arteries of downtown, was taken at Harvey (Dean A. McGee) Avenue. To the left of the photograph is the Illinois Hotel, which was a very popular spot for customers for its third-floor balcony overlooking Main Street. To the right of the photograph is the Columbus Buggy Co. (Griffith Archives.)*

LUCKY MEN, 1907. The message on the back of the postcard reads, "1907, young men I use to go with, Horace, Hicks and Holbrook." (Griffith Archives.)*

YOU'RE THE ONLY GIRL I EVER LOVED – BUT I CAN'T KEEP TELLING YOU SO, ALL THE TIME

WHAT A COINCIDENCE. . .The back of this commercial postcard reads "Dr. Holbrook, to Florance. Could it be the same fellow? It's nice to think so." (Griffith Archives.)*

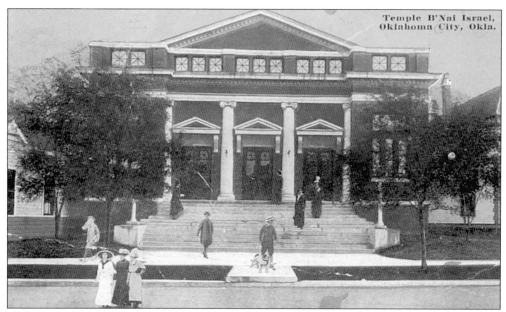

TEMPLE OF B'NAI ISRAEL, 1907. Built in 1907, the temple was not formally dedicated until January 17–18, 1908. Located at 50 Broadway Avenue Circle, it was built at a cost of $12,000. In 1907, Rabbi Joseph Blatt assisted with the planning and construction of the temple for the Jewish population, which numbered 275. (Griffith Archives.)

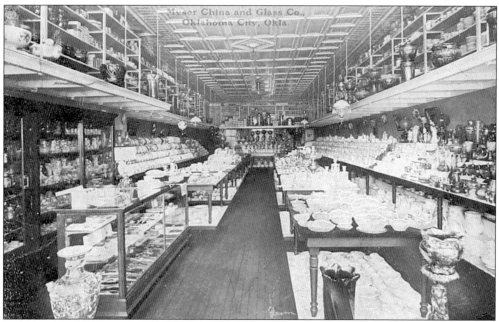

NO ELEPHANTS PLEASE, 1907. The Myser China and Glass Company was located at 116 West Main Street from 1907 until 1909. Before the days of Tupperware and aluminum, glassware and china were not only indicative of status but quite functional and necessary. Ladies could also purchase blank pieces of china for painting. (Griffith Archives.)

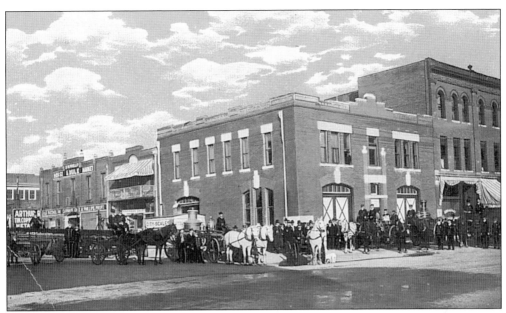

CENTRAL FIRE STATION, c. 1907. The first fire brigade was organized on September 3, 1889, when the first fire broke out in Oklahoma Station. This view shows the fire department with a Holloway Chemical Engine, Ramsey Horse Wagon, and a hook and ladder. The staff consisted of four full-time and 13 volunteer firefighters who were paid 50¢ for each fire. (Griffith Archives.)

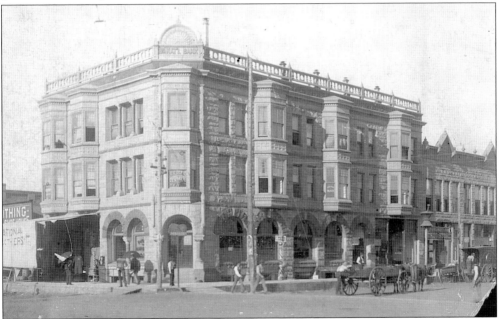

HUCKINS ESTATE BUILDING, c. 1907. This building was originally a rooming house with iron beds, chamber pots, and other marks of distinction. The Saddle Restaurant occupied the first floor. When the building was converted into office suites, a few less-than-desirable tenants moved in. These included a bookie, a gambling establishment, and an abortionist. The First National Bank had moved in when this photograph was taken. (Griffith Archives.)*

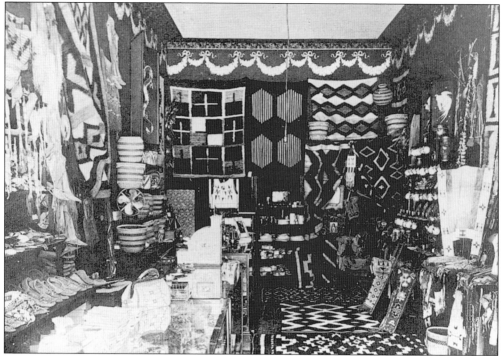

OKLAHOMA CURIO SHOP, *c. 1907.* H.H. Clark and his wife, Opal, sold cigars and newspapers as well as "native curios" in their shop at 28 North Harvey Street. They operated it from 1905 through 1908. (John Dunning "Okie Archives.")*

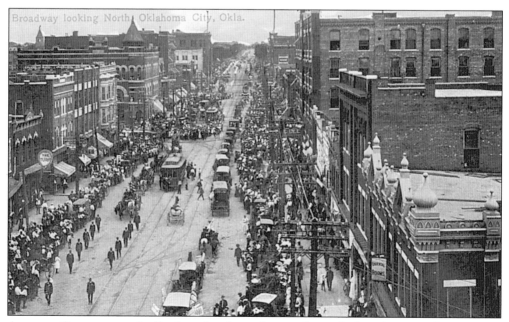

ALWAYS A CELEBRATION. Led by the police force, this parade marched south on Broadway Avenue followed by a horse-drawn fire wagon, pulled by Jumbo and Babe. Oklahoma City has always been supportive of parades for various civic groups and patriotic events. (Griffith Archives.)

120

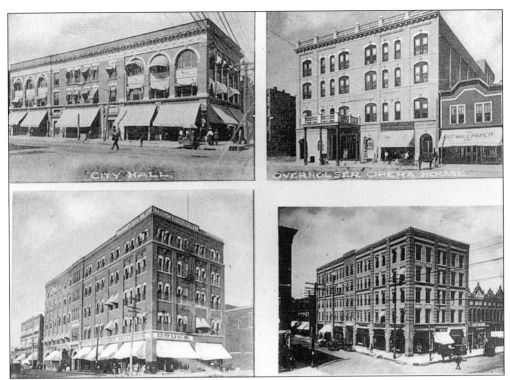

FOUR PRINCIPLE BUILDINGS. City Hall at Grand and Broadway Avenues, the Overholser Opera House at 217 West Grand Avenue, the Baltimore Building at Grand Avenue and Harvey Avenues, and the Lee Building at Main Street and Robinson Avenue were all very important structures. (John Dunning "Okie Archives.")

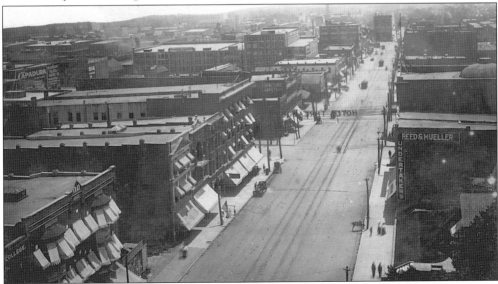

REED & MUELLER UNDERTAKERS. This view of Broadway Avenue is looking to the south from Fourth Street. On the right is the Reed & Mueller Undertakers, located at 307 North Broadway Avenue (phone 570), while the Empire Theater can be seen on the left, midway in the photograph. The Culbertson Building sits at the "jog" on Grand Avenue. (Griffith Archives.)*

121

STAFFORD, 1903. This photograph of Roy E. Stafford, editor of the *Oklahoman*, was taken by John Woods. (Charles Turner Hocker Collection of the Archives & Manuscripts Division of OHS.)*

CAPABLE DRIVER AT THE REINS. This advertisement photograph for Ewing Studios, located at 405 North Robinson Avenue, was taken just before a parade. The two photographs attached to the carriage are, from left to right, the Oklahoma Military Institute (Oklahoma College for Young Ladies) and the Colcord Mansion. (John Dunning "Okie Archives.")*

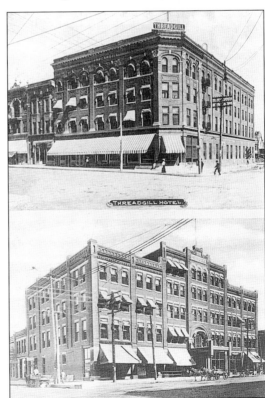

ONLY THE FINEST. Shown here are additional views of the Hotel Threadgill and the Hotel Lee. (John Dunning "Okie Archives.")

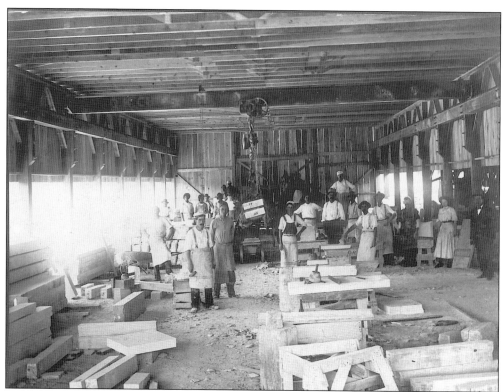

HAVE STONE, WILL CUT, c. 1907. This photograph was taken of the O.K. Cut Stone employees at 716-722 West Second Street. (Archives & Manuscripts Division of OHS.)*

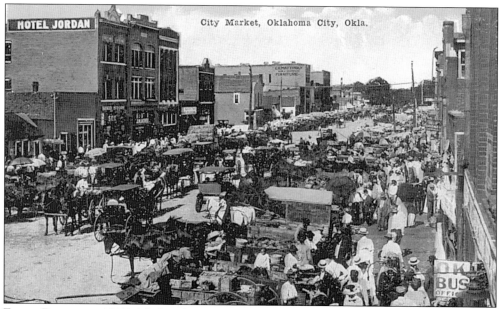

FRESH PRODUCE, 1907. Market day was on Saturday mornings as this scene of farmers and merchants in the 100 block of W California Street illustrates. The Hotel Jordan was owned and managed by Mrs. I.M. Jordan. (Griffith Archives.)

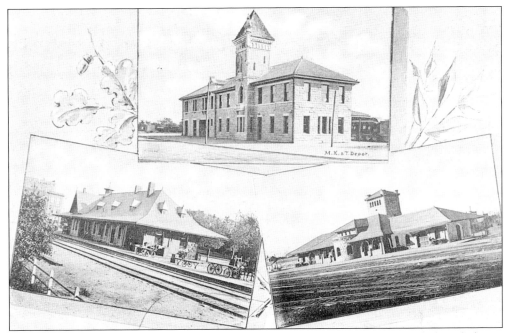

RAILROAD DEPOTS. The top photograph shows the Missouri, Kansas, & Texas (Katy) depot, which also serviced the Fort Smith & Western, located on Reno Boulevard (east of the Santa Fe tracks). To the left is the St. Louis & San Francisco (Frisco) depot, located on the north side of First Street, between Harvey and Hudson Avenues. The right photograph shows the Atchinson, Topeka, & Santa Fe depot off of California Avenue. (John Dunning "Okie Archives.")

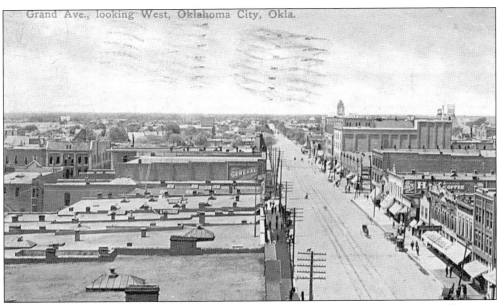

GRAND AVENUE LOOKING WEST, c. 1907. In this scene, one can see, to the right, the tower of the county courthouse, followed by the 1903 Overholser Opera House, and six of Henry Overholser's pre-fabricated buildings. In 1910, Charles Colcord built a 12-story office building on that corner. (Griffith Archives.)

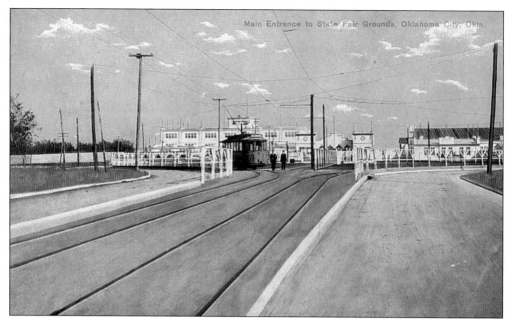

MAIN ENTRANCE, c. 1907. Henry Overholser purchased enough property along Eighth Street to have the majority vote in swaying a proposed property tax to have the street paved for the opening of the first State Fair of Oklahoma. (Griffith Archives.)

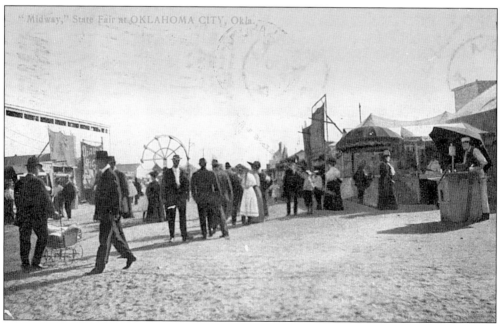

MIDWAY c. 1907. On October 5, 1907, the first state fair opened, and some 10,000 patrons are said to have entered the gates. The Missouri, Kansas, & Texas Railroad ran a 15-minute shuttle train to the fairgrounds on this occasion. (Griffith Archives.)

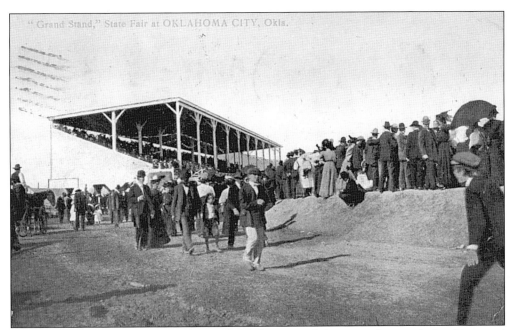

STANDING ROOM ONLY. More than 15,000 fans crowded into and around the fairground grandstand. General admission cost 50¢, reserved seats cost 75¢, and box seating sold for $1. Gambling was heavy, with legal bookmakers and touts shouting their willingness to do business. (Griffith Archives.)

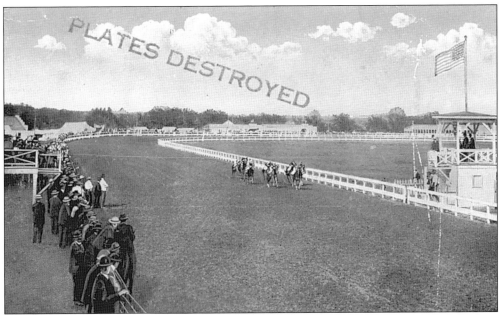

PLATES DESTROYED, c. 1907. Horse races had been staged only three months after the Run and were repeated at every possible opportunity. The territorial fairs of 1892 and 1894 featured races, as had the street fair of 1898. On October 10, 1907, the Oklahoma Derby, a one-mile race, was the highlight of the state fair. (Griffith Archives).

127

CHEERS, 1907. These gentlemen salute the camera for one last hurrah before the wet territory becomes a dry state. (Griffith Archives.)*

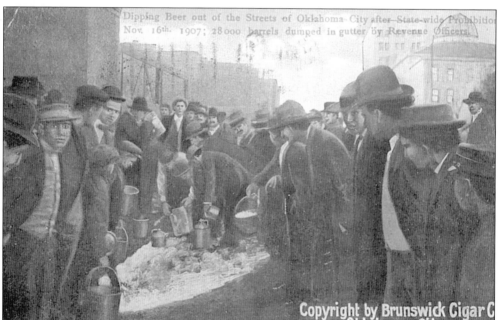

Dipping Beer out of the Streets of Oklahoma City after State-wide Prohibition Nov. 16th. 1907; 28 000 barrels dumped in gutter by Revenue Officers

Copyright by Brunswick Cigar C

THE BEER FLOWED ON STATEHOOD DAY. Revenue officers are shown baptizing the streets and gutters with beer. Some 28,000 barrels were dumped the day Oklahoma became a state on November 16, 1907. (Griffith Archives.)